Quattuor Regna in Pace

The Dragon Chronicles

The Lost Journals
of the
Great Wizard, Septimus Agorius

COURAGE BOOKS

AN IMPRINT OF RUNNING PRESS
PHILADELPHIA • LONDON

Library of Congress Cataloging–in-Publication Number 2002102855

ISBN 0-7624-2077-4

First published in Great Britain in 2002 by Pegasus Publishing Ltd.
High Street Limpsfield, Surrey RH8 0DY

Design and Jacket design: Malcolm Sanders and Garry Walton
Principal illustrations by Garry Walton
Additional artwork contributed by Robin Koni, Steve Read, Paul Westrup and Chris Hiett

This book may be ordered by mail from the publisher.
But try your bookstore first!

Published by Courage Books, an imprint of
Running Press Book Publishers
125 South Twenty-second Street
Philadelphia, Pennsylvania 19103-4399

Visit us on the web!
www.runningpress.com

Contents

Publisher's note

The book you hold in your hands is a faithful reproduction of a document that was brought to auction in London's antique trade during the mid-1800s. Its provenance is uncertain and carbon dating has thus far failed to provide a reliable indication of its true age but the family who owned it at that time, the Stranacks of Sellerton Hall, maintained that it was a true record of actual events and that it had been in their possession for at least 400 years.

In an effort to establish the veracity of their claim, and presumably to drive up the asking price, senior family member Gareth Stranack presented the material to the Royal Geographical Society shortly before auction but by all accounts he was firmly and scornfully rebuffed by its representatives.

The best estimate that modern science can make, based on the navigational maps that appear in the book, is that it would have to be at least 1500 years old if genuine. Our attention has been drawn to a missing page that has long been the subject of speculation amongst historians, some of whom believe it to have contained specific instructions from the Wizard to his young apprentice. Others have suggested, rather more ominously, that the page may have included notes relating to the raising of Demonica, in which case it would undoubtedly have been removed by the author as a precaution against possible misuse.

Much of the text contained in the original manuscript was barely legible, especially on the pages where specimens and samples had stained the parchment, and since the narrative itself was written in an obscure and ancient tongue, language specialists were called in to provide the translation you read here. These enhancements were felt by the publisher to be necessary but everything else was photographed exactly as presented by the current owner, who wishes to remain anonymous. We are reliably informed that the original has now been returned to a secure vault somewhere in Scotland.

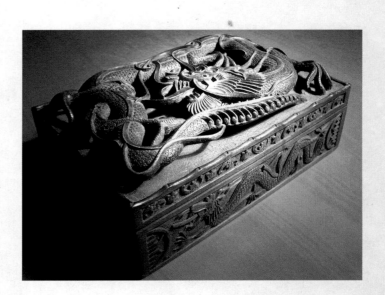

1991 photograph illustrating the beautifully carved casket in which the book is currently kept. It is not known whether this is the original box or whether it was constructed at some time during the intervening centuries to provide for the safekeeping of the journal.

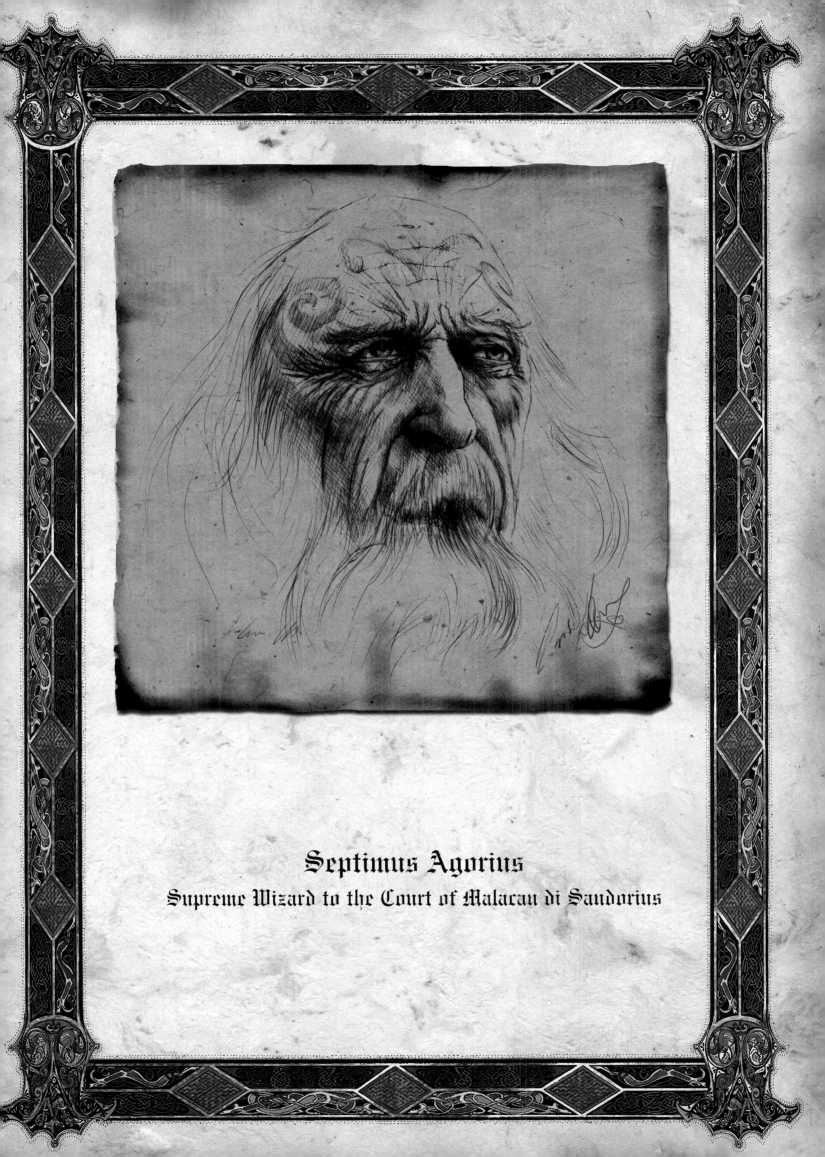

Septimus Agorius
Supreme Wizard to the Court of Malacau di Sandorius

The Four

Quattuor

Arrean Mountains

Gordacas Canyon

Western Kingdom

Amandan Forest

Tremana

Sea of Aleph

Archipelago of Denisarnda

Arken Island

The Isles of Waltan

Phara

Brooke's Bay

Avarigan Pla

Ursicus Castle

Southern Kingdom

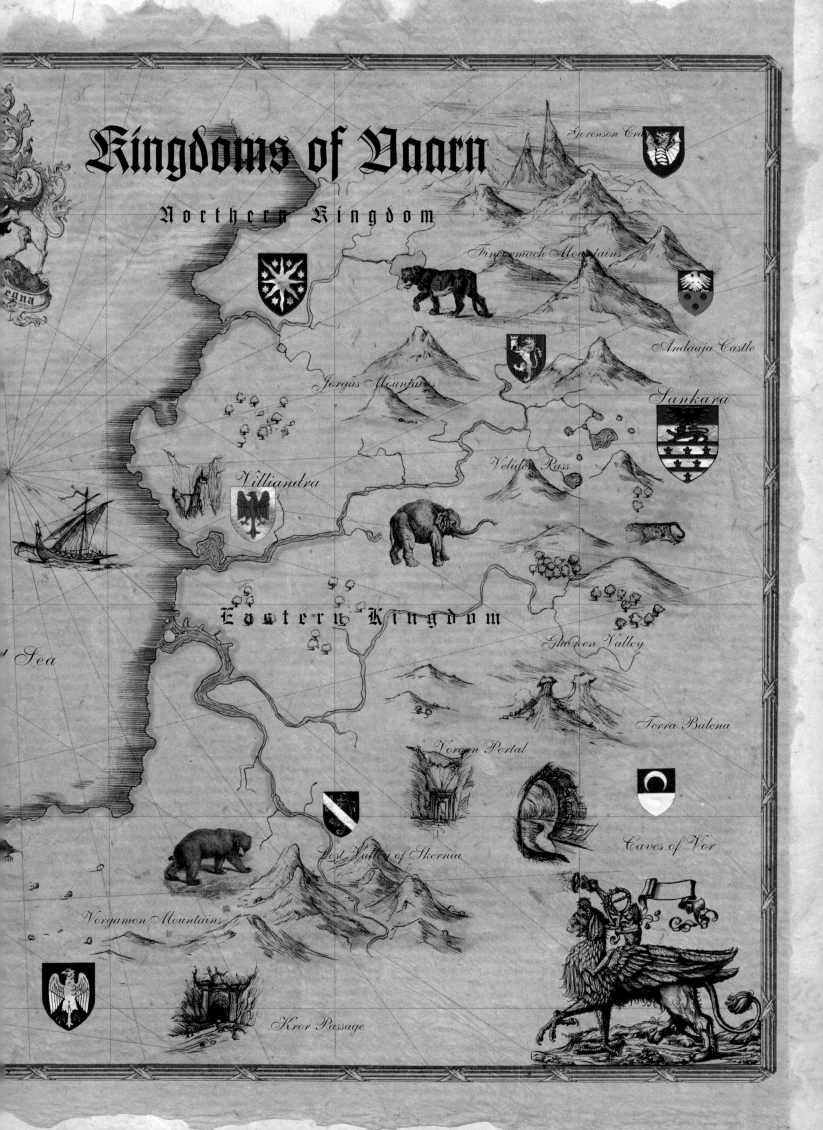

Kingdoms of Vaarn

Northern Kingdom

Gorenson Cra

Fincermach Mountains

Jorgas Mountains

Andaaja Castle

Sankara

Villiandra

Veliden Pass

Eastern Kingdom

Ghorzen Valley

Sea

Terra Balena

Voreen Portal

Lost Valley of Skernia

Caves of Vor

Vorgamon Mountains

Kror Passage

Chapter One

♦

A Letter from the King

I am Septimus Agorius, Supreme Wizard to the Court of Malacan di Sandorius, Sovereign Ruler of the Four Kingdoms of Vaarn.

It is now fully one month since the King's messenger came to my chambers late that night and the letter he bore rests beside me now – a heartfelt plea from the man I have come to regard as Lord, Master, and true friend. On learning of the King's failing health I rushed immediately to his side, taking with me a few herbal preparations to ease his pain.

I arrived early the following morning and as I sat down beside him he summoned what remained of his once considerable strength to grip my hand.
' You must do this for me,' was all he said, and as I looked deep into his tired eyes he repeated this one sentence many times over, growing more delirious as the hours passed and the terrible illness slowly claimed his mind.

My heart was heavy as I gave him the assurance he sought, not because I was reluctant to grant his dying wish or because I feared for my own life but because the mission his letter had described was almost certainly doomed to failure. The enormity of the task was beyond his comprehension and yet it had to be attempted for the sake of our people.

It was late afternoon when I eventually left the King's chamber, bidding my friend farewell in the almost certain knowledge that I would never see him alive again.

As I walked back along a dark corridor towards the main part of the castle, my head hung low in sorrow, a courtier suddenly appeared from a side passage and ushered me into a small, dimly lit antechamber. On the desk before us lay a finely embossed gold casket. The courtier slowly removed the lid and, with the utmost reverence, eased the mighty tome out of the deep red cushioned lining of the casket and passed it to me. The King had not exaggerated. The book in which I was to record my journey and upon which I make this entry was indeed beautiful and very strong. My friend had made sure that whatever misfortunes befell us in the months ahead this great book would be equal to the rigours of the quest.

Gently, I released the gold clasp that sealed the book and began to turn the pages, each of which was fashioned from the finest parchment. As I neared the back cover I motioned to the courtier to avert his eyes, for if the King had indeed made the legendary Sankara Amulet available to me then it would surely be secreted here. I myself had not seen the Amulet since the battle of Carnverion which took place some one hundred years ago, but as my hand fell on the final page of the book I recognised the unmistakable turquoise glow of the stone beneath. I turned the leaf and once again found myself entranced by the Amulet's beauty. A small velvet-lined recess had been created within the hard cover of the book and it was here that the Amulet rested, retained by an ornate metal brace. A soft, gently pulsing light emanated from the centre of the stone, briefly illuminating the darkened room. For a few moments I allowed my mind to travel back through the distant past, recalling the various myths and legends in which the amulet was alleged to have played its part. Though many of the stories were apocryphal, I knew from my own experiences that the Amulet's power was beyond doubt. I knew too that it had been the servant of masters both good and evil, and that the responsibility associated with being its temporary guardian was therefore considerable. As I closed the book and replaced it in the casket the courtier once again turned to face me, bidding me good fortune as he handed me a specially crafted leather bag in which to carry the book. I thanked him before quietly taking my leave and making my way back through the shadowy corridors to the main gate.

Day One

The day of our departure dawned bright and clear. A thin mist hung in the vast natural harbour which rings the port of Villiandra way below my clifftop home and from a small window in the corner of the room I could see the last of the provisions being loaded onto the four ships the King provided for us. By noon it was high tide and the strong easterly breeze that sweeps down the valley from the Jorgas mountains at this time of year was set to carry us on our way. I read the King's letter one more time before placing it carefully in the opening pages of the book and I resolved that it will never leave my side.

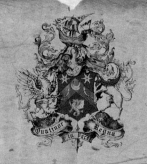

My Dear Septimus,

Many are the tribulations I have endured throughout my long reign over the Four Kingdoms yet your unfailing guidance and friendship have sustained me, just as they sustained my father during his rule and his father before him. Your powers are indeed formidable and your knowledge unsurpassed.

My friend, were you able to restore my health now that it is fading I know that you would do so. I know also that a Wizard's magic, however great, may not disturb the natural order of life and death and so I accept my fate. It pains me to tell you that I am growing weaker by the hour and I fear that the end of my earthly days will not be long in coming.

My greatest regret is that there is one more thing I must ask of you, Septimus, before I depart this world. This task is so daunting that I can scarcely bring myself to set down the words upon this page and the very idea that I should have to ask it of one who has served me so well brings me close to tears. Please try to find it in your heart to forgive me, for I know of no one else who could attempt such a mission.

You will have heard, I am sure, about a fearsome malevolence which is rising in our world. Many a long year has passed without threat from the dragons which reside in the Kingdoms save for their occasional attacks on our livestock but something has changed. Our villages are under siege and many of our subjects have been taken by these terrible beasts. I am not given to understand why the dragons have turned against us but my dying wish is that I should rid my people of this appalling curse. There have been rumours that the exiled wizard, Ganzicus, has set himself against us and is commanding the dragons with evil intent. History records a similar event one thousand years ago when the wrath of the dragons was visited upon the world but few survived to speak of that cataclysm and how it came to pass. All I can tell you is that it came to be known as 'The Dragon Storm'.

And so, Septimus, what I must ask of you is this: I will put at your disposal one hundred of my fiercest warriors, four ships and all the necessary provisions for the journey if you will seek out these dragons and destroy them. The Sankara Amulet, which has been held securely in the castle vaults since the reign of my Great-grandfather, will of course be made available to you should you accept the commission. It cannot protect you from serious harm but the eye of Sankara, preserved in the centre of the Amulet, has many properties which are well known to you.

It is my wish that my son, Bandred, accompany you on the journey despite the dangers you will undoubtedly face for he has much to learn before he is worthy of my title. He is headstrong, and such is the spirit of youth, but he has always shown great interest in your teachings and I believe your guidance will help him win the respect of our people. Had my health not failed me I would have waited longer before initiating Bandred but my hand has been forced. I hope you agree that he is ready and trust that you will protect him as best you can during your travels together. In time he will make a great King. Of this I am sure.

Lastly, I must ask you to document your expedition and gather such artefacts as you deem relevant for it is possible that, should your mission fail, there will be others who are brave enough to meet the challenge and follow in your footsteps. Their chances of success may indeed be poor but the knowledge you have acquired on your travels will serve them well, echoing through the centuries as a testament to your efforts and those of the courageous individuals who aided you.

Three of the finest artists from my Court will also accompany your team, recording the encounters in sketches and paintings whilst assisting in the collection and preservation of samples. As I write this, a master craftsman is working through the night to create a book of great strength and rare beauty according to my design. You must keep it with you at all times since it contains a small compartment which provides for the safekeeping of the Amulet. An abundance of parchment leaves on which the artists can make their entries forms the main body of the tome, which will henceforth be known as 'The Dragon Chronicles'.

I wish you good fortune, and need not remind you of the urgency of the task which awaits you.
Your very great friend,

Malacan di Sandorius
Sovereign Ruler of the Four Kingdoms

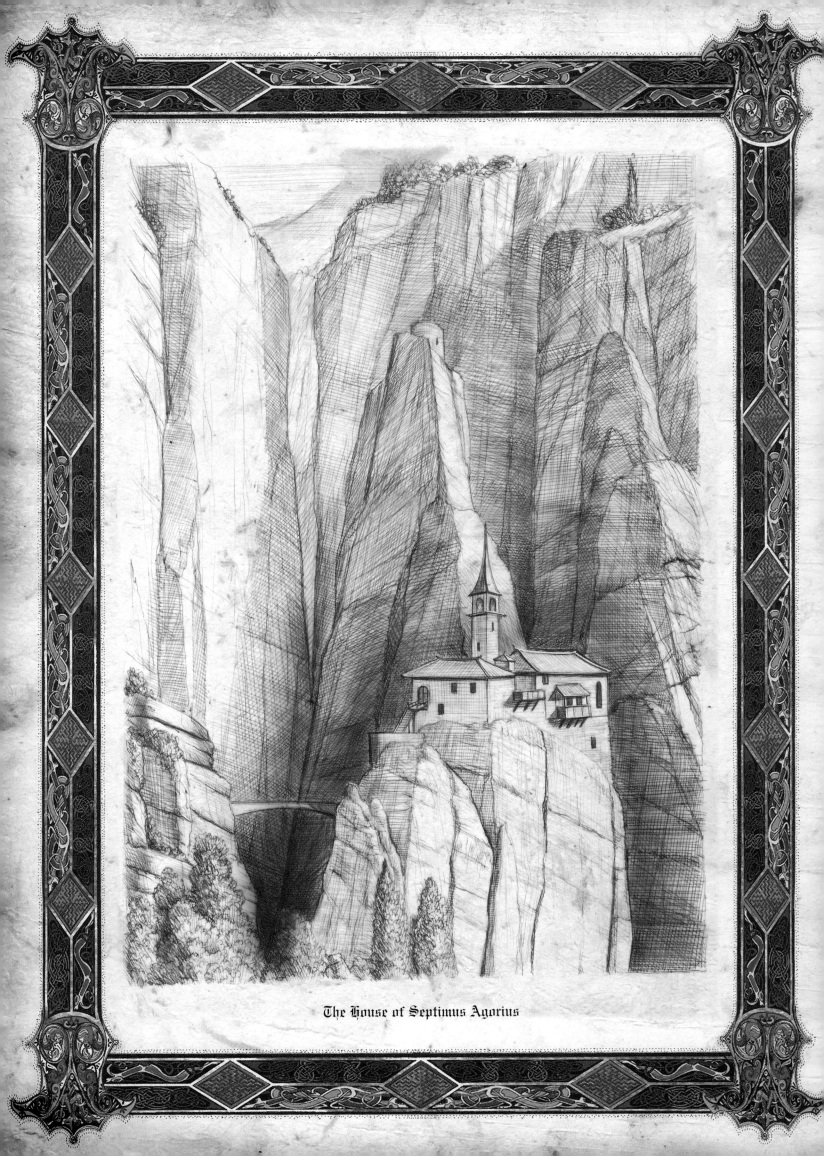

The House of Septimus Agorius

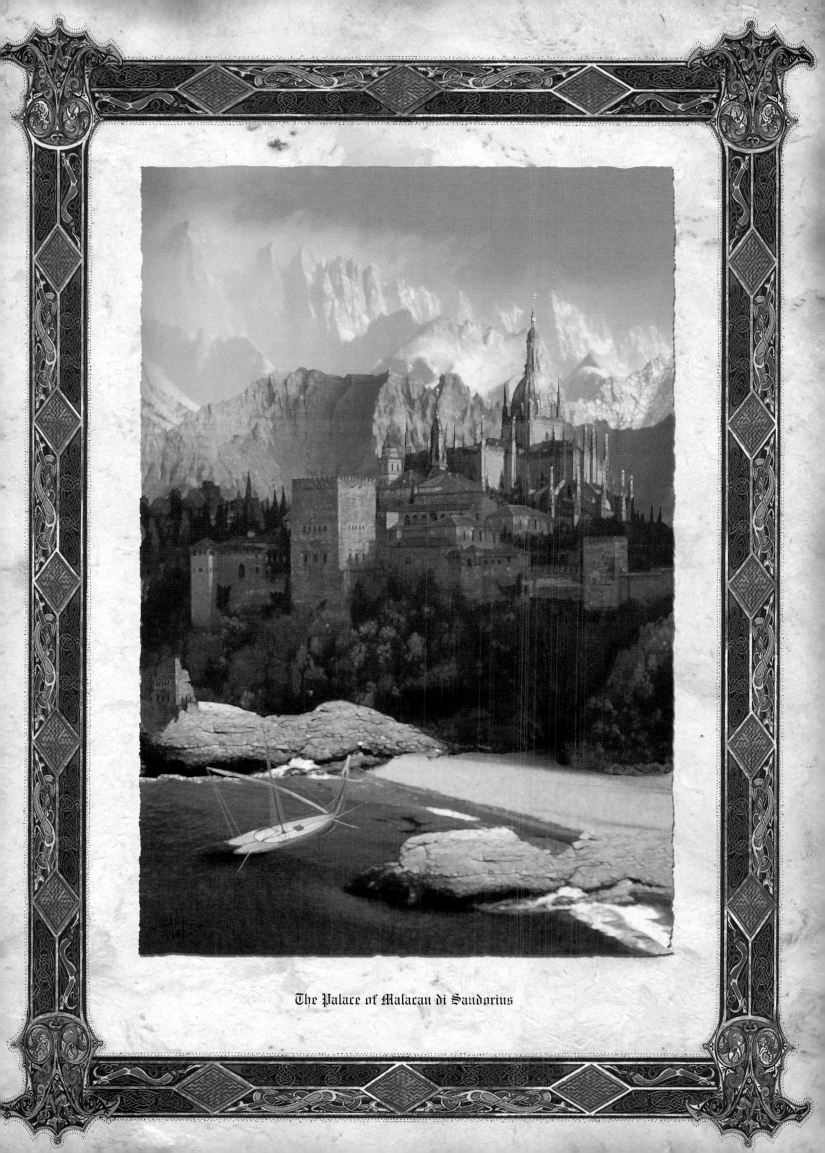

The Palace of Malaran di Sandorius

When the knock at my door finally came I was standing on a terrace looking out at the ocean and trying to imagine the battles that lay ahead. The arrival of the porters shook my reverie and I lead them through to an area where a large wooden crate had been assembled containing almost all the knowledge, materials and equipment I have gathered over these past three hundred years. As I watched the unsteady progress of the porters down the steep track towards the harbour I prayed that the crate would be safely delivered to the scenes of these dreadful encounters, for there cannot be the faintest hope of victory without it. When the time came for me to leave I placed the book in a specially made leather sling that hangs loosely over my right shoulder, threw on my cloak and started down the path towards the ships. Mindful of missing the turning tide, we departed almost immediately.

Chapter Two

♦

Westwards to Tremana

Day Three

For the first three days we have made good progress under sail. Having nothing of particular importance to record during the initial stages of our journey, the artists on board our vessel today amused themselves by making sketches of some of their fellow crew members and giving imaginary names to the seabirds which followed in our wake.

It had been decided to head West because word had reached us shortly before our departure of renewed and increasingly violent activity in the Third Kingdom. There could be no doubt that the dragon attacks, once confined to livestock and occasional assaults on lone individuals who had strayed too far into the hills, had increased greatly in magnitude and number. The latest incident had reportedly occurred in the foothills of the Arrean Mountains, a relatively low area, where an old man had been slain as he farmed his crops.

Day four

The winds that have carried us so far in the first few days have now blown themselves out and our ships are becalmed. We are making some progress thanks to the efforts of our oarsmen but the mood has grown noticeably darker as, for the first time, the men begin to contemplate their fate. At around noon there was a brief moment of levity when we were hailed by one of the other ships. It appeared that they have discovered a stowaway in the grain store – a girl of about sixteen who gave her name as 'Amaleh'. She was winched across to our vessel and when I questioned her she explained that she'd overheard one of the warriors talking about our mission back at the port and was unable to resist the adventure. We both knew that it was too late to turn back and the girl seemed likeable enough, so I told her she can earn her passage by serving as my assistant until we make landfall.

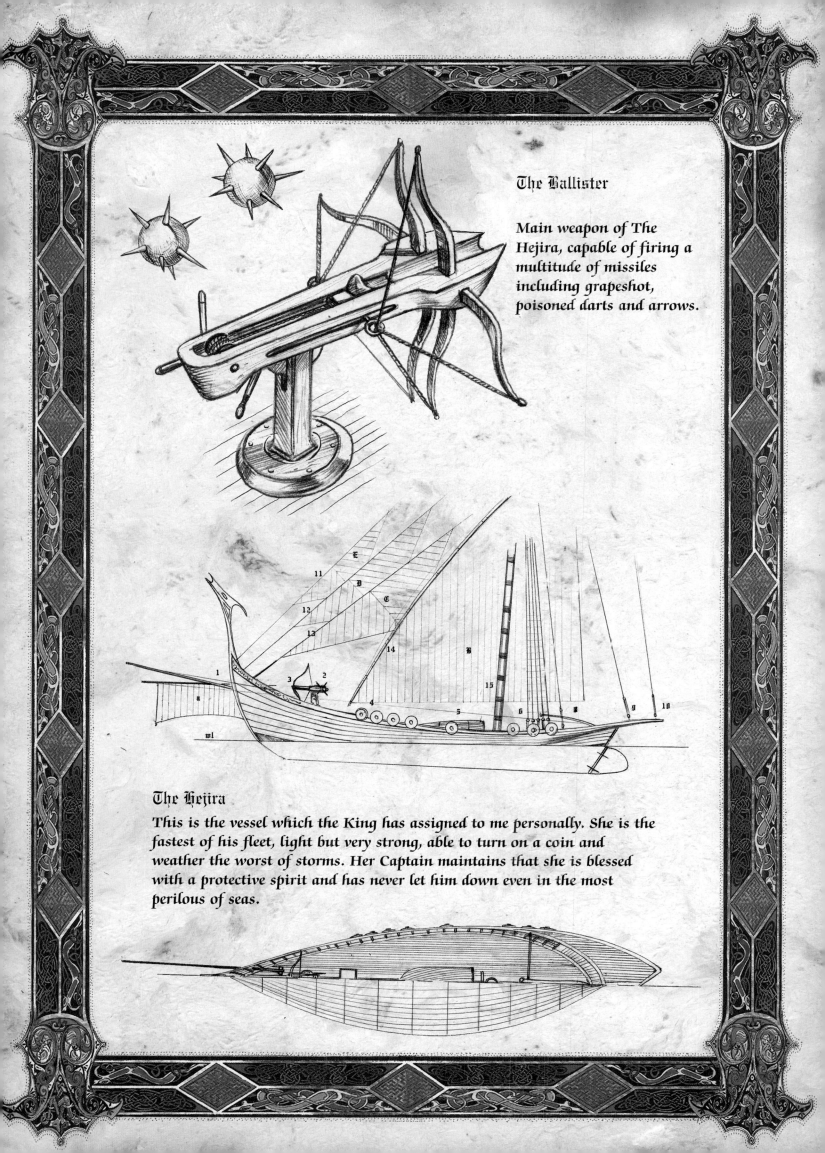

The Ballister

Main weapon of The Hejira, capable of firing a multitude of missiles including grapeshot, poisoned darts and arrows.

The Hejira

This is the vessel which the King has assigned to me personally. She is the fastest of his fleet, light but very strong, able to turn on a coin and weather the worst of storms. Her Captain maintains that she is blessed with a protective spirit and has never let him down even in the most perilous of seas.

We were passing between a series of small islands at dusk when I first heard the lookout's cry. He pointed to a patch of sea in the middle distance where the water's surface was boiling angrily. Dark clouds swirled in the sky above and although it was unlike anything I have ever seen before I knew instinctively that something evil was about to rise from the depths.

The ship's sails began to snap back and forth, cracking loudly as vicious gusts ripped into the canvas. Across the water I could hear agitated cries from our compatriots on the other vessels and there could be no doubt that they were right to be afraid. Experienced seafarers one and all, they knew that Mother Nature herself, for all her violent moods, could never conjure up a storm such as this within the few short minutes that had passed. By now the water immediately ahead of us was heaving ominously and great plumes of spray were being hurled into the air where the waves pounded a jagged rocky outcrop on our starboard side.

I looked up and was momentarily awestruck by the sky above us. Never before have I seen the elements exhibit such fury and yet there was a terrible beauty to the black clouds which spiralled overhead, twisting and turning in on themselves as lightning bolts slashed through their dark, seething forms.

I rushed below deck in the full knowledge that the opportunity for preparing our defence against this threat would be brief indeed. The ship began to pitch violently as I rifled through a great trunk seeking the equipment I would need. Hurrying back through a corridor I found Bandred emerging from his cabin and, with all the sternness I could muster, bade him return to the relative safety of his bunk.

Back on the main deck the scene that greeted me was one of chaos. It was dark as night by now and the crew worked furiously to secure all the loose objects on board and strip the sails. Returning to the bow I found my worst fears confirmed.

A dark funnel of cloud was slowly descending from the centre of the maelstrom and within it something unspeakable was beginning to take shape. Out of the corner of my eye I could see Amaleh cowering in a small storage compartment at the side of the deck and I ordered her below. She was too terrified to move, however, and I had not the time to escort her, so I turned my attention to the contents of the small cloth bag I'd retrieved from the trunk. In front of me a low plinth provided just enough space for the ritual I would have to perform. I cursed the stiffness of my ageing hands as I fought to undo the bag's drawstring and release the nine flattish pebbles contained within. Eventually they spilled out, bouncing off one another and skidding off the foam-flecked wooden surface of the plinth.

To form the Sacred Circle and generate the energy required, the outer ring of eight stones must all be touching each other and the ninth must be placed in the very centre, something that became harder and harder to achieve as the conditions progressively worsened. Once I nearly had the formation but the ship was struck by a great wave that shook her to the core and sent the stones tumbling across the deck. At that moment we crested another huge wave and as we plunged downwards into the relative calm of the watery canyon between the peaks I made another desperate attempt to complete the pattern. After failing again I realised that it was only by beaching on the lee side of the approaching land mass that we would be able to find a stable base on which to perform the ceremony and a few moments later, skilfully guided by our Captain, we found our vessel heaving itself into a shingle bay and rolling onto its side. Amaleh decided to break cover, finding in herself a renewed courage as she darted from the shadows to assist me. In the darkness we could search the island only by the light of the brief but intense lightning flashes and by the time we'd located a suitable vantage point our foe was fully formed, its immense bulk towering over us like the embodiment of evil itself. A grotesque head, half dragon and half serpent, jutted forward from the main column of swirling wind and water on a barbed and scaly neck.

At the sides its claws were clearly visible but most terrifying of all was the creature's cry, a guttural scream which melded with the ocean's roar to produce a noise of such extreme ferocity that it shook the ground on which we stood.

The leading vessel was now no more than a few seconds away from the base of the tornado. It was impossible for me to determine whether this fearsome apparition was merely composed of the elements or whether it had somehow metamorphosed into flesh and blood, thereby acquiring the ability to attack in the manner of other beasts. Either way, we were all in grave danger since the tornado itself would surely tear our vessels to shreds even if the monster could not. The outer ring of pebbles was ready and as I dropped the ninth stone into place it was immediately apparent that the alignment had been perfect. A powerful white light, like a miniature lightning bolt, raced around the outer ring, bathing the stones in its glow. Amaleh stood to one side of me, her look of terror now having given way to one of sheer wonderment as the strange light illuminated her features. A second later the ring of energy arced into the centre pebble just as I knew it would and I recognised this as the moment to strike. Without hesitation, I touched the crystal orb at the tip of my staff to the central stone and felt the familiar jolt as the supernatural power coursed through its length.

The staff acts as a conductor and it was crucial that my aim was true if we were to avoid an appalling fate. For a brief but agonising moment nothing happened and then the orb suddenly filled with light. The staff kicked again and as I raised it skywards an intense flash streaked up through the darkness, piercing the gloom. The victorious cries of our fellow travellers could be heard above the din of the ocean as the energy stream found its target and a second later the sky appeared to burst open as the creature itself exploded with cataclysmic force, raining debris all around. So violent was the blast that we were all thrown off our feet and as the pebbles scattered once again I found myself unable to prevent at least two of them from bouncing across the rock surface and dropping into the ocean, where they would remain beyond use for all time.

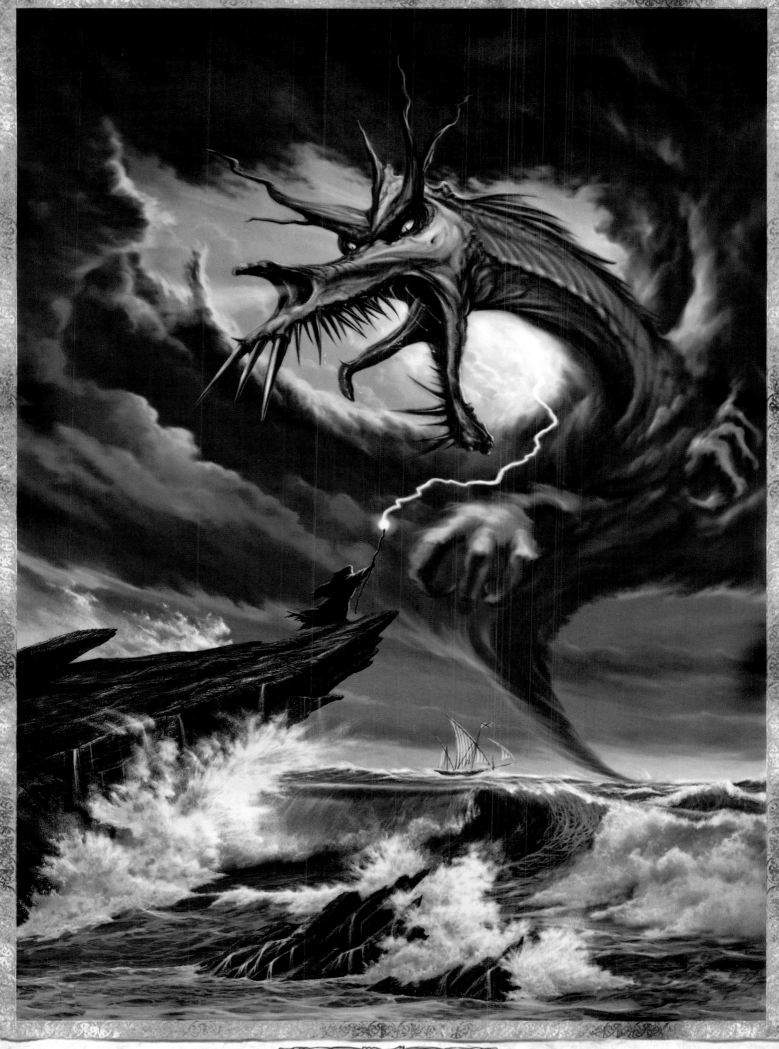

Our crew was jubilant but I was not so sure that the danger had passed. The tornado that had spawned the monster now appeared to be dissipating and spiralling into the ocean but as the seas around us calmed I began to feel more uneasy than ever. No more than a couple of minutes had passed before the ocean was completely still again, the tornado having blown itself out.

Still the dark clouds loomed overhead, circling with less urgency than before but maintaining their threat of evil. A cry from a crew member on the leading ship, The Verana, heralded the peril we were about to face. We couldn't make out his words but shortly afterwards our ears were assailed by the roar of the phenomenon that had so alarmed him. Not three leagues distant, at the point where the tornado had disappeared, an enormous whirlpool had formed in the ocean's surface. I watched with horror as The Verana banked sharply into the revolving wall of water and embarked on its final, desperate journey. Our oarsmen, along with those of the other vessels, immediately rushed below decks and set about the task of turning the ships around.

If a similar fate was to be avoided our other ships would need to put a good stretch of clear water between themselves and this gaping maw in the ocean's surface as quickly as possible. As our own vessel pushed back through the surf and came about I could see only the tip of The Verana's main mast, now making its third circuit of the thunderous whirlpool. She appeared to be moving faster and faster in the ever tightening funnel of water and there was absolutely nothing I could do to save those on board. I watched with several other crew members as she disappeared from view, dragged down into the unimaginable darkness of the ocean's depths.

Gradually the roar subsided and the skies at last began to clear. For now, at least, we were safe. We took a new bearing and collected a few items that we found floating near the point where The Verana had been taken down before resuming our journey, assisted by the light Easterly wind which now filled our sails.

Exhausted and deeply saddened by the day's events, I had not intended to make further entries in the journal tonight but, as I sit here now, the page in front of me lit only by the faint glow of a candle, my mind begins to travel back to the distant past.

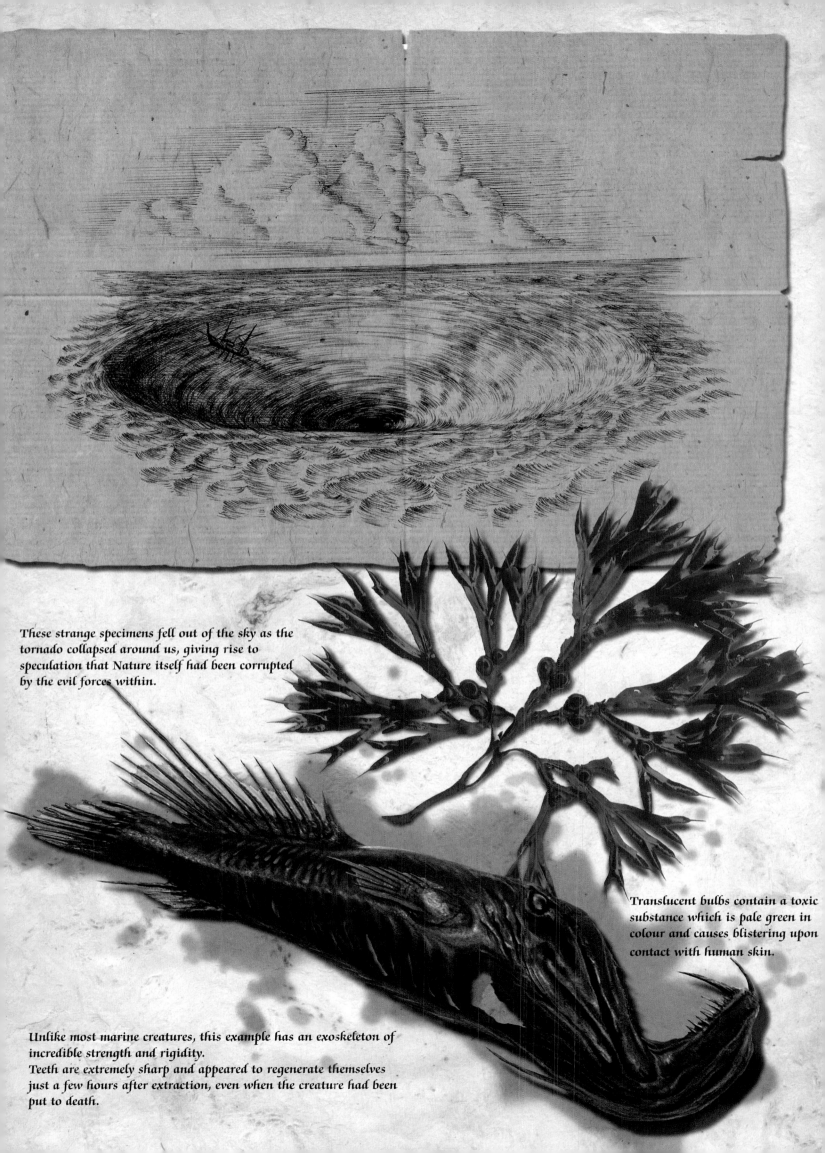

These strange specimens fell out of the sky as the tornado collapsed around us, giving rise to speculation that Nature itself had been corrupted by the evil forces within.

Translucent bulbs contain a toxic substance which is pale green in colour and causes blistering upon contact with human skin.

Unlike most marine creatures, this example has an exoskeleton of incredible strength and rigidity.
Teeth are extremely sharp and appeared to regenerate themselves just a few hours after extraction, even when the creature had been put to death.

Many years ago a Wizard called Ganzicus, whose powers were at least the equal of my own, served alongside me in the Court of our ruler Malacan di Sandorius. There was peace throughout the Kingdoms during that period and he worked with me harmoniously for quite some time before beginning to grow resentful of my friendship with the King. In truth, Malacan extended no favours to me that he would not have extended to my colleague but as time went by and Ganzicus's imaginings took hold he slowly withdrew his services, ultimately making only occasional appearances at the King's Court.

A few months later I was approached by one of Ganzicus's apprentices who'd become fearful of his master's wrath after interrupting him in the midst of a dark ritual. I confronted Ganzicus in the expectation that some kind of misunderstanding had occurred but he was defiant when I questioned him, aggressively and somewhat mysteriously declaring himself answerable only to an authority higher than my own. When, shortly afterwards, the apprentice suddenly disappeared I had no alternative but to tell the King what I knew.

Ganzicus was duly summoned and a dreadful argument ensued, the culmination of which was the King's decision to banish Ganzicus to one of the Northern islands. Unable to exile Ganzicus against his wishes, Malacan was forced to enlist my help in carrying out the deed, an act that further enraged Ganzicus and confirmed his sense of betrayal.

And now we have come to this. The King made mention of Ganzicus in his letter and in the light of today's events I can be sure that his suspicions were well founded. The creature that attacked us today could have been the work of none other than Ganzicus himself.

Day Six

We have made good progress for the last two days but the mood on board has been solemn. This morning we sighted Arken Island on the far horizon. Its craggy cliffs rose sharply out of an otherwise featureless ocean and its peaks reached skywards like the gnarled fingers of a drowning man. Most of those on board knew it to be the place where Ganzicus now resided and they stared fixedly at its forbidding profile as we passed by.

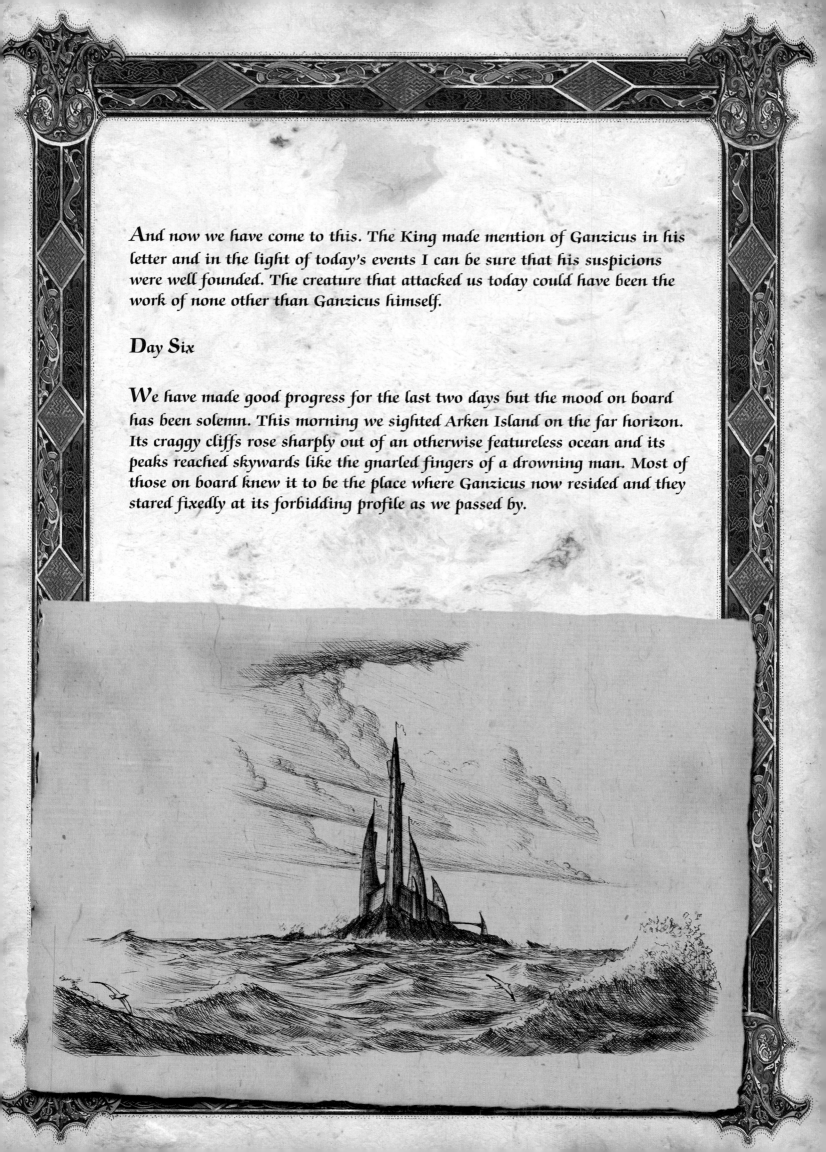

The Captain of our vessel later reported to me that he had noticed a marked change in the shape of Arken Island since he was last in these waters. The rocky peaks had now been joined by a cluster of colossal towers, darker even than the grey granite that surrounded them, and we were forced to conclude that Ganzicus had built a fortress on the island.

Briefly, the thought occurred to me that we could divert Northwards and seek Ganzicus himself, rather than pursue the great beasts he now appeared to command, but on reflection I realised how foolhardy this course of action would have been. The waters around Arken Island are extremely perilous at this time of year and were we to make landfall successfully and find our quarry in residence, we would have been confronting Ganzicus at the height of his powers.

The rest of the day passed without incident and I spent several hours demonstrating simple magic to young Bandred. Like his father, he shows great determination and strength of character but he has very little instinctive feeling for the Ways of Wizardry. It frustrates him so but I try to explain that the qualities he does possess will one day make him a truly worthy King, which I know to be true. There is something different about the young girl, though. She is usually a fiery little waif but she spent all afternoon sitting cross-legged, watching Bandred and me without uttering a single word. I could sense her understanding of much that I said, however, and when I shot an occasional glance in her direction she met my eyes with a look that spoke to me of the wisdom of centuries.

Chapter Three

◆

The Farmer's Tale

Day Seven

We reached safe harbour in the Third Kingd… [obscured]
much of the afternoon was spent unloading t… [obscured]
bustling port and our arrival appeared to cau… [obscured]
the local townspeople, all of whom were most… [obscured]
well at a nearby Inn and retired early, relieve… [obscured]

Late at night there came a knock at my door… [obscured]
the Captain of one of our ships. The young… [obscured]
had never seen before, but he was introduced… [obscured]
farmer who had recently witnessed a fatal at… [obscured]
dragon. Over the years he had seen this same… [obscured]
occasions, but always at a great distance hig… [obscured]
learned that he and his family had worked a… [obscured]
for many years, making a modest living by s… [obscured]
town's market once a week. With a tremulou… [obscured]
terrible events that had overtaken them one afternoon in the Autumn of last
year.

He'd been ploughing a field at the head of the valley when a great shadow
swept over him. Looking up, he'd been horrified to see what he assumed to
be the Beast of Gremarnaca circling low overhead. Tearfully, he explained to
me how he'd desperately tried to warn his family of the danger as they toiled
in the neighbouring fields, but that his voice had been carried away on the
breeze.

According to his account the dragon had banked sharply, swooping so low
over his head that the great gust from its wings threw him off his horse.
Terrified, he'd lain face down in the soil for a few moments, and when he
raised his head he beheld a sight so terrible that it will, I fear, stay with him
until the end of his days. The creature had landed nearby, pinning a farmer
to the ground with one of its enormous claws. Varien had immediately
recognised the victim as his father and rushed to his aid, joining others who
had quickly improvised weapons from their working tools.

There was nothing to be done, however, since the beast was all but oblivious to their efforts. It would not be distracted from its prey, whose writhing and screaming brought no release form the unrelenting grip of the dragon's talons.

Again and again the creature's heads lunged downwards, ripping great chunks of flesh from the old man's ragged body, and only occasionally did they snake sideways, snarling and threatening to strike at those who baited the creature with hoes and scythes. In desperation, Varien had run straight at the beast, driving a fence post forcefully into the side of one of its mouths. With a terrible cry, it leapt upwards, beating the air powerfully with its wings and creating dust clouds of such density that the farmers were left temporarily blinded and gasping for breath. As the air cleared the dragon could be seen heading back towards its mountain lair, the lifeless body of Varien's father still dangling in its grip.

Varien sobbed openly as he neared the end of his sorry tale. He had not returned to the farm since the attack and lived instead with friends in the port, still unable to accept the sad fact of his father's death and his failure to prevent it. When at last I asked him whether there was anyone who could take us to the scene of the struggle his reaction initially surprised me. 'I will escort you myself at first light,'was all he said, and after a moment I understood just why it was so important to him.

Day Eight

Varien was as good as his word, and our small army of horses and warriors left Tremana early this morning, making only slow progress in the grey mist of dawn. I also have my suspicions that many of our company were suffering from an excess of revelry last night, since their faces were entirely bereft of good cheer.

By mid-morning we were well inland but recent rain had caused a considerable softening of the ground. It proved extremely difficult to move the heavier equipment along the deteriorating tracks and at one point the soldiers nearly exhausted themselves trying to dislodge the giant crossbow from a mud bank where it was stuck fast.

When a team of six horses failed to wrench it free the decision was taken to dismantle it and so we incurred a further delay. It was almost dark when we eventually reached Varien's smallholding, so we pitched camp and resolved to begin our inspection of the area in the morning.

Day Nine

The grey mist that has dogged our journey since we left Tremana had lifted by the time we woke this morning and the clear sky that greeted us appeared to raise everyone's spirits. Varien led us to the area where the attack had taken place but it would not have been difficult to locate even without his help, since signs of the struggle were all around. The broken implements which the family had used in their futile attempts to fight off the creature lay where they were dropped and despite the rains there were still traces of the old man's blood in the soil. Adjacent to this discoloured patch of earth lay the fence post that Varien had employed in his last desperate assault on the creature. We bowed our heads respectfully as he retrieved the post and retired to a mossy bank, before sitting down and burying his face in his hands.

It was only then that we felt it right to begin a close examination of the site. Our hope is that by learning as much as we can about these beasts and their behaviour we will greatly improve our chances of destroying them in battle. Before long one of our team uncovered a broken tooth in the damp soil. It was almost certainly dislodged by Varien's final blow and when we showed it to him he nodded in recognition. He allowed himself a half smile since our discovery did at least prove that he was able to inflict some kind of retaliatory injury on the dragon before it took flight.

Unable to find any further specimens worth including in the journal after a thorough search of the area, our artists were forced to make speculative sketches illustrating the creature's method of attack based on Varien's detailed account of the incident and the teeth marks they found on some of the wooden implements.

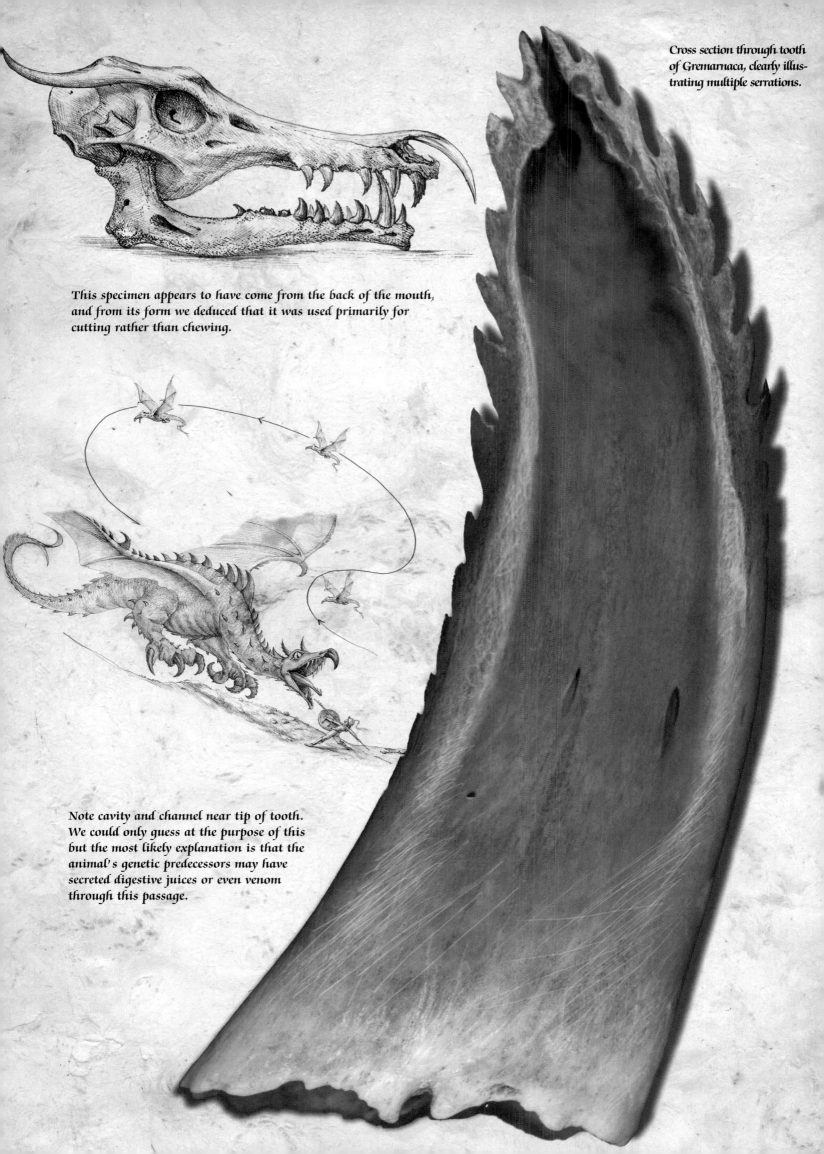

Cross section through tooth of Gremarnaca, clearly illustrating multiple serrations.

This specimen appears to have come from the back of the mouth, and from its form we deduced that it was used primarily for cutting rather than chewing.

Note cavity and channel near tip of tooth. We could only guess at the purpose of this but the most likely explanation is that the animal's genetic predecessors may have secreted digestive juices or even venom through this passage.

I have to say that I've been most impressed by the abilities of the artists whom the King assigned to our mission. Although their respective specialities vary considerably, they all work quickly and accurately whether drawing from life or imagination and I have no doubt that their contributions to the journal will provide a more informative record of our encounters than any of my written accounts could do.

By nightfall we had learned all we could from the site so it just remained for us to perform a simple ceremony marking the passing of Varien's father. At my request one of the artists carved the old man's name on the fence post his son had used in his attempts to save him and this was duly erected on a low ridge overlooking the smallholding.

Day Ten

With the coming of dawn we bade farewell to Varien but not before he had indicated to us the area of mountains where he presumed the creature's lair to be. He had motioned to a jagged outcrop of rock in the high peaks and provided a crude map on which a series of loosely interconnected tracks were drawn. These tracks, if they still existed and were yet passable, would lead us to the Beast of Gremarnaca.

We pressed onwards as quickly as we could, intent on gaining as much height as possible before fading light marked the end of another day. This evening we made camp at the entrance to Gordacas Canyon, a natural geological formation of outstanding scale and grandeur.

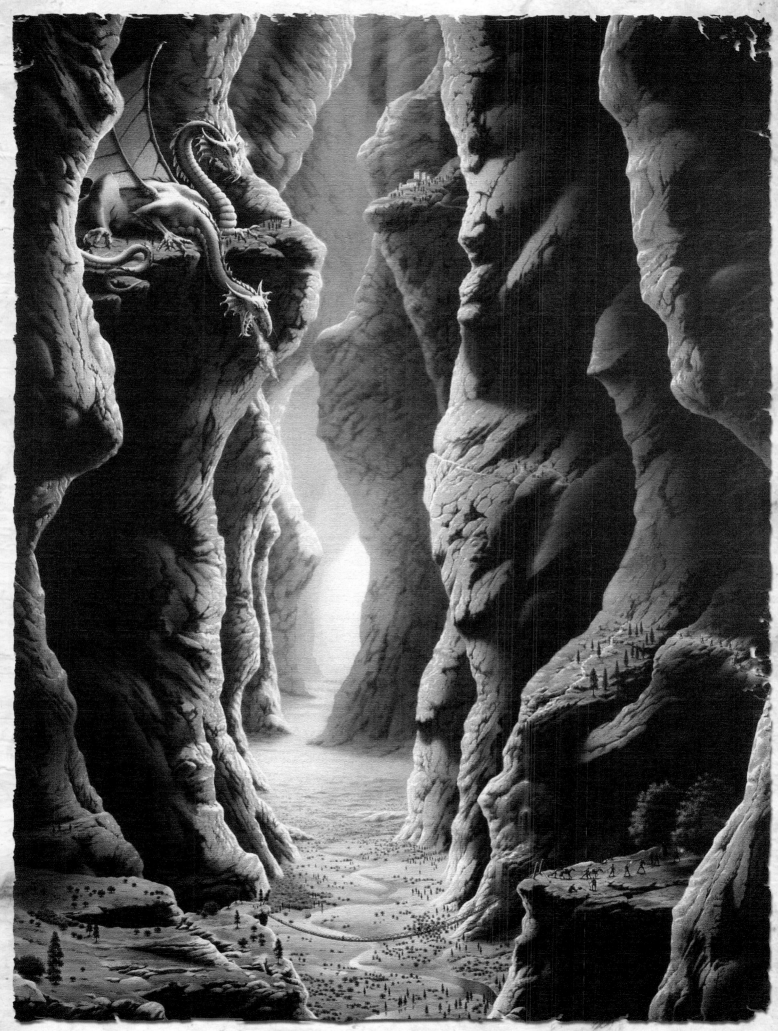

Day Eleven

Our intention had been to resume the climb at first light but we awoke to fierce winds that delayed the dismantling of the tents and hampered our every movement. It was apparent from the way the canyon's walls had been eroded that such winds were a common occurrence in these parts but this knowledge did nothing to lessen our discomfort as we struggled to maintain our footing in the difficult terrain. When at last the gusts subsided we were able to gain a little more height but the path grew more and more tortuous as the hours passed, snaking back and forth as it slowly ascended the canyon wall. Greatly fatigued, we eventually sighted a small plateau just ahead of us and planned to rest there awhile but tragedy overtook us before we reached it.

I heard a sharp cry from one of the horsemen near the back of the group and looked over my shoulder in an effort to identify the cause of his pain. He was quite some way distant from me and my view back down the path was partially obscured by the rest of our entourage.

Intermittent glimpses revealed a figure flailing his arms about in a frantic attempt to beat off a small winged creature resembling a bat. At first his predicament was the cause of some mirth amongst the other warriors. Here was a man of great strength and courage on a mission to slay dragons struggling to defend himself against the most insignificant of creatures. Only when he screamed, clutched his eye, and fell heavily to the ground did the laughter begin to fade.

I suddenly realised that the animal we had all assumed to be a bat was in reality something far more sinister and dangerous. Dragonets are the piranhas of the dragon world, highly aggressive and extremely powerful for their size. I had seen them only once before but knew from that encounter just how deadly they can be, savaging their victims in a mad frenzy of tooth and claw. Some were no larger than the span of a man's hand but when they attack in a great swarm, as is their habit, there is no creature large or powerful enough to withstand the vicious onslaught.

A few men rushed to the fallen warrior's aid but by now I could hear other cries coming from within the group. Raised swords sliced the air but were too unwieldy to strike effectively at the creatures that reeled overhead, squawking and cackling with what sounded like malevolent glee. The main body of the swarm would not be far behind and I hurriedly scanned the gloomy recesses of the vast gorge in an effort to ascertain the probable direction of attack. My gaze quickly fell upon a swirling black cloud further along the canyon and although I had known it was coming, the sight of the swarm made me sick to my stomach. It appeared to move slowly at first, swelling a little and then receding, like a plague of locusts in flight. Parts of the cloud seemed to push outwards from time to time, giving rise to the impression that the swarm might have been one huge amorphous creature, which in a way it was. The cacophony of shrieks reached us a few seconds later, amplified and echoed by the great stone walls which barred our escape.

I knew that it was within my power to protect our army from this foe but only if they were to cooperate fully and swiftly with my instructions and trust me implicitly. In normal circumstances it would have been impossible to make myself heard above the rising crescendo, so I filled my lungs with air, drew deeply on my powers and, in a voice which rang out like thunder, bellowed my instructions to the group behind me.
'Stand absolutely still and restrain the livestock as best you can!'

By the time my command had reached the men's ears, the swarm was almost upon us and the noise had risen to a pitch of such extreme intensity that many of the foot-soldiers simply dropped to the ground with their hands clasped tightly over their ears. I clambered onto the wagon in which Bandred and Amaleh had been riding and, seeing the fear in their faces, bade them lie down in the back before covering them with rough blankets. The swarm was at my back when I made a great sweep of the air with my staff, describing an arc that contained the entire army. The words I spoke as I did so have been known to me for many a long year, an incantation that empowers the sacred orb at the staff's tip and creates an invisible protective shell of limited strength and stability but considerable size. If there is too much movement amongst those sheltering within, then the integrity of the bubble is undermined. It may grow weak in places or even dissolve altogether, hence my order to the soldiers.

At best, it will hold its form for a few precious minutes and provide a shield strong enough to repel small objects or animals. A running man would have sufficient mass to penetrate it but a dragonet, even diving from a great height, would not. The invisible ceiling above our heads also served to mute the creatures' cries, so I was able to repeat my order to the soldiers, imploring them to stand firm even as the dragonets began the first wave of their attack. A few of the men could not help recoiling as, one after another, the creatures either glanced off the unseen barrier or crashed straight into it with a sickening crunch. Those whose shallow angle of approach had allowed them a second chance merely circled the canyon and repeated the manoeuvre with even greater force until they too had either broken their wings on the shield or worn themselves out in their attempts to pierce it.

Of greater threat were the few dragonets trapped within, most of which had arrived before I was able to raise the protective dome. They had now been joined by a couple which had managed to break through where the thickness of the shield had been compromised by the horses' panic-stricken attempts to flee the scene. I estimated there to be about six of them in total and on finding themselves imprisoned they seemed intent on inflicting as much injury as possible on their captors. In addition to their needle-like teeth and claws, which are sharp enough to tear leather, the dragonet has another weapon that is even more formidable. Like the scorpion, to which it is related, is has a raised tail with a deadly sting. A successful strike will render a man paralysed in minutes and result in an excruciating death over the following few hours. I know of no cure and my magic is powerless to extract the venom from the victim's bloodstream once it has taken hold.

As the shield gradually dissipated and most of these last few demented creatures took flight, one of them, its wing too badly damaged to allow it to escape, attached itself to the scalp of a mounted soldier just a short distance from where I was standing. With a defiant shriek it buried its sting deep in the man's neck before dropping back to the ground. Another soldier immediately pinned it to the earth with a broadsword and crushed its skull underfoot but his actions served no purpose beyond revenge. The stricken warrior had already slumped forward onto the neck of his horse and was emitting a low, mournful groan.

Jubilant in victory and obviously much relieved to be safe once again, some of those who had not witnessed this last attack began a spontaneous round of applause. I was forced to silence them as we lifted the injured soldier off his horse and, with the utmost care, lowered him slowly into one of the wagons. We reached the plateau not long afterwards but his condition was deteriorating rapidly. A temporary camp was set up and we made the soldier as comfortable as we could but I knew the end would not be long in coming. Less than two hours after the initial attack we had committed his body to the grave, marking his resting place with a large pile of granite slabs.

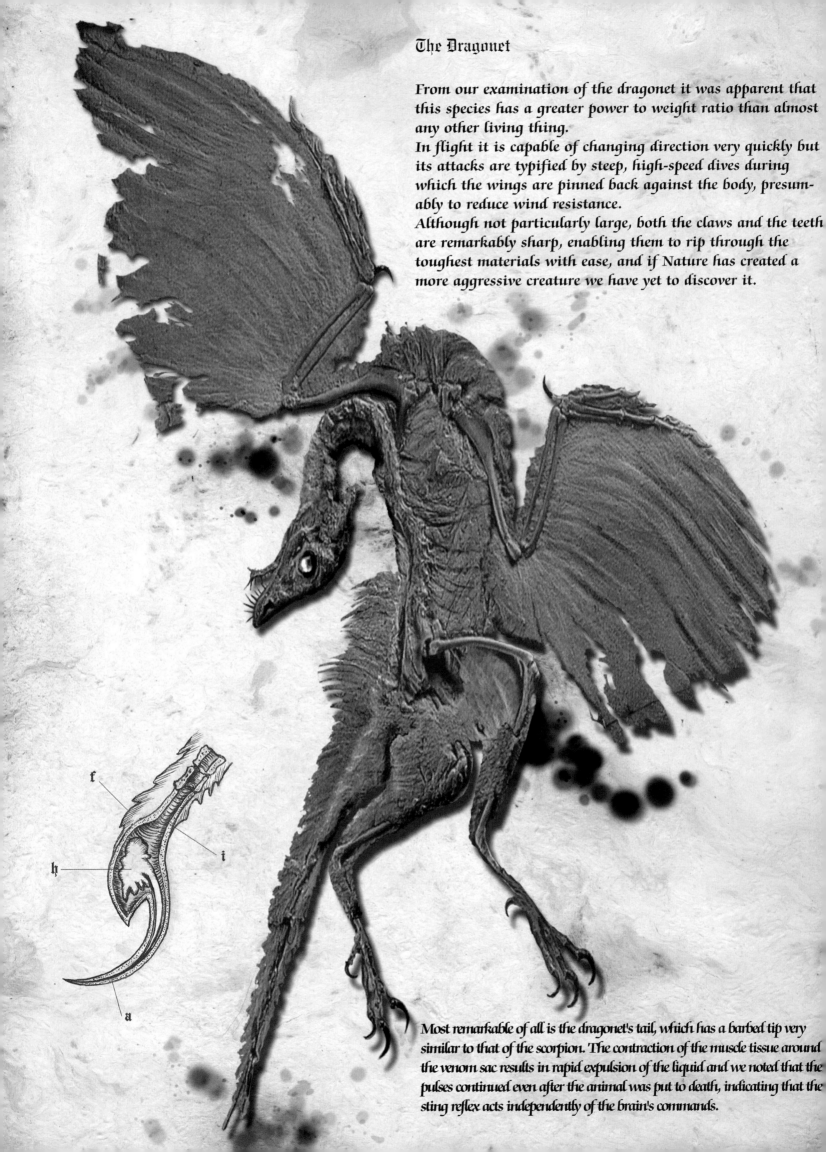

The Dragonet

From our examination of the dragonet it was apparent that this species has a greater power to weight ratio than almost any other living thing.

In flight it is capable of changing direction very quickly but its attacks are typified by steep, high-speed dives during which the wings are pinned back against the body, presumably to reduce wind resistance.

Although not particularly large, both the claws and the teeth are remarkably sharp, enabling them to rip through the toughest materials with ease, and if Nature has created a more aggressive creature we have yet to discover it.

Most remarkable of all is the dragonet's tail, which has a barbed tip very similar to that of the scorpion. The contraction of the muscle tissue around the venom sac results in rapid expulsion of the liquid and we noted that the pulses continued even after the animal was put to death, indicating that the sting reflex acts independently of the brain's commands.

We proceeded on our way, eyes still focused on the sky ahead lest there be a repeat of this dreadful incident. By dusk we were nearing the upper reaches of the canyon and although most of the men were keen to be free of its confines there could be no doubt that the walls afforded a degree of shelter from the elements. It was therefore decided that we would pitch camp for the night under a broad overhang near the point where the rising path finally breached the top of the near-vertical cliffs.

Day Twelve

This morning I was awakened by a cry from one of our scouts. He had risen early with the intention of planning a route that would ensure our safe passage and was eager to show me what he had found. I took with me a telescope and the two of us clambered up a steep slope to a vantage point that yielded a spectacular view of the Arrean peaks. The scout motioned towards a natural gully that had formed between two rocky outcrops and, although it was difficult to establish the scale at this distance, clearly some kind of giant nest had been constructed within this relatively sheltered area. The true size of it became more apparent as I panned across the rock face with the telescope. It was not unlike the sort of eyrie an eagle would create for itself but, instead of small branches, this nest was made up of what appeared to be fully mature pine trees. It had to be the Beast of Gremarnaca's lair although, judging by the width of the nest, which would scarcely have been spanned by seven of our wagons laid end to end, the creature itself was likely to be rather larger than any of us had anticipated. There was no sign of life but we felt very exposed on the open ridge, so we wasted no time in returning to camp.

Once again I had cause to refer to Varien's map, which despite certain inaccuracies had served us well thus far, bringing us to the head of the canyon in only three days. As I traced the various paths with the end of my finger it quickly became apparent that we had in truth reached journey's end. The track we were using would climb higher but it would take us no nearer to the beast's lair than our current position, veering to the right instead and snaking up through another pass to a different part of the mountains. We were as near to the nest as it was possible to get and yet it was still well beyond the reach of our weaponry. Even the huge wooden Madagan crossbow we had brought with us had barely half the range we would need and would serve only to provoke an attack. I summoned the Captain and we considered our options.

Chapter Four

Betrayal

Day Twelve-Afternoon

My meeting with Captain Kronson was barely underway when we were suddenly interrupted by a strange noise outside the tent. We looked out to see our men pointing down the canyon and speaking in whispers. The sound we had heard was the wing beat of the Beast of Gremarnaca, big lazy strokes that lifted its great bulk ever higher and almost drowned out the desperate cries of the tiny figure that dangled from its talons. Another victim that was beyond my help.

I ordered the men to return to the safety of the overhang and they obeyed most readily. As we watched from the shadows the creature glided past without seeing us and I was later informed by the scout that it had returned to the nest and made short work of its meal. It was obvious to me that our only hope of destroying the creature was to bring it within range of our weapons and the Captain agreed. We would position a catapult such that it would hurl boulders into the far wall of the canyon and on hearing these great crashes the creature would surely venture out to investigate their source. Only then would we unleash the lance from the giant crossbow, which would remain hidden in the darkest recesses of the overhang. The plan was immediately put into action but we repeatedly failed to provoke the beast. Some of the boulders thudded uselessly into soft earth and the loud cracks generated by those that struck the rock face were too similar to the sounds produced by a nearby glacier to attract any attention.

Reluctantly, I came to the conclusion that human bait would be required to lure the creature from its lair and since my skills afford me some protection from attack it seemed only right that I should be the one to offer myself up. After checking that everything was ready I again ascended the ridge I had climbed earlier.

The dragon was still on the nest and both its heads were pointed in my general direction but at first it failed to notice me. Only when I performed a simple spell which created a shimmering arc of green light in the air above me did the great heads slowly rise from the edge of the nest. A few moments later the creature was airborne, bearing down on me at a speed that caught me off my guard. I was still a short distance from the point where the path drops below the ridge when it made its first pass, swooping low and creating a downdraft of such force that it sent me tumbling across the rocks. By the time the dragon had made a circuit of the canyon, however, I was limping towards the relative safety of the overhang, confident by now that it would move in for the kill. Instead, it made several high-speed dives at the area where we were hiding, each time peeling off at the last moment with a terrifying cry. Evidently, the creature was too suspicious to effect a landing and it began to seem increasingly unlikely that we would get the clear shot we needed.

Suddenly, from somewhere behind me, a figure darted out of the darkness. It was the boy Bandred, and he was moving so fast that I had no chance of intercepting him. A second later he had cleared the protective canopy of the overhang and reached an open section of the path, where he was in full view of the creature. Mindful of my promise to the King, I immediately ran after the boy and threw him to the ground, covering his body with my own. Raising my head a second later, I was horrified to see a pair of giant talons gripping an outcrop of rock just a short distance ahead of us. The creature was so close that we could smell its rank odour and even feel its hot breath on the backs of our necks. Bandred strained to see but I forced his head down with my hand and with my free arm I gave the signal to fire. The great lance passed so low over our heads that we felt the rush of its slipstream but before we could react it had struck home, driving deep into the dragon's underbelly with a resounding thump. Tempered many times over in the King's own foundries, the metal tip had been designed to penetrate the scales and lodge firmly in the soft tissue underneath, before releasing a potent toxin into the creature's bloodstream.

The Madagan Crossbow

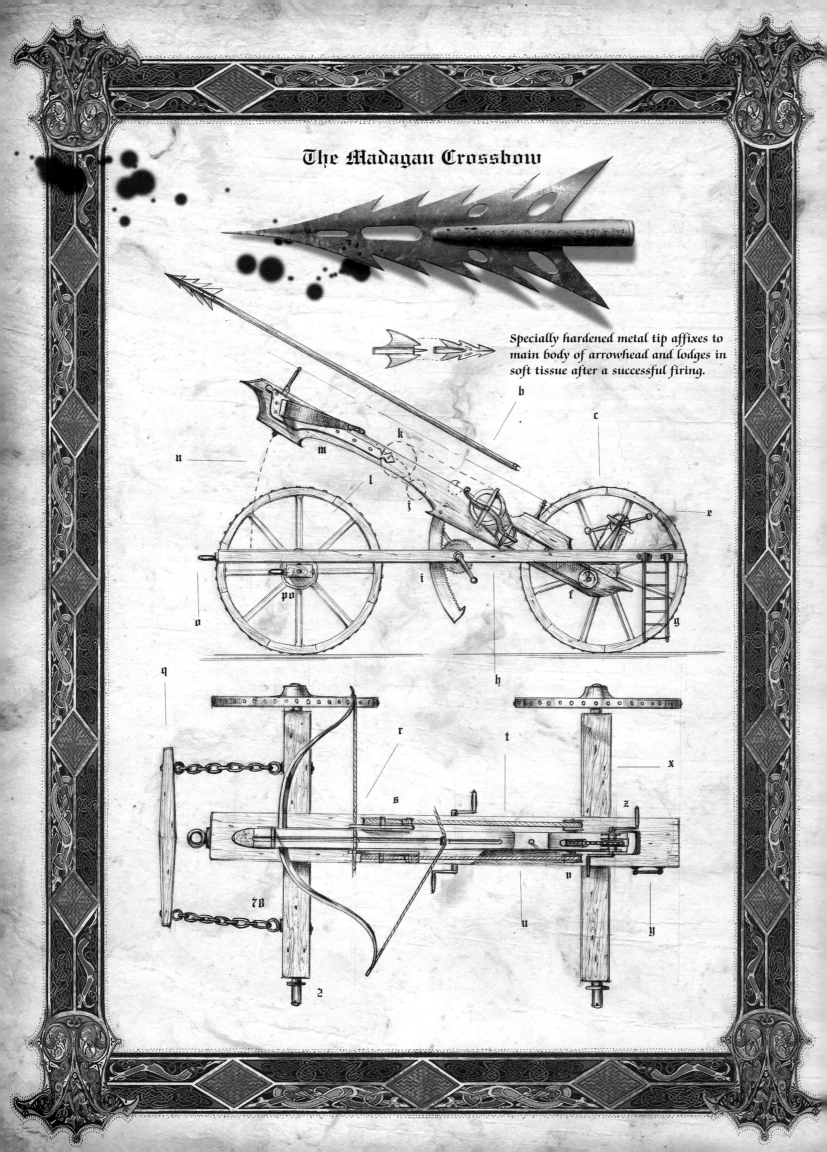

Specially hardened metal tip affixes to main body of arrowhead and lodges in soft tissue after a successful firing.

The sheer force of the impact caused the beast to reel backwards, slipping off the path and dropping into clear air with a scream which echoed throughout the gorge. A cheer went up and everyone rushed forward to the edge of the precipice, whereupon we were rewarded with the sight of the dragon going through its death throes on the canyon floor far below. As I retire tonight I draw some comfort from the day's events, for although there are many such encounters ahead of us, we have at least proved ourselves equal to the challenge.

Day Thirteen

Late last night, Amaleh came to my tent and roused me from my slumber with a warning that I did not at first comprehend. Her expression was deeply troubled and her eyes darted from side to side as she spoke, her words delivered in a nervous whisper…
'I felt a voice! I felt a voice!'

When I tried to correct her, suggesting that she must have heard a voice, she insisted that I was wrong and went on to tell me that the voice she'd felt was that of Captain Archemon, one of the highest-ranking warriors in our battalion. As she calmed down I began to understand a little more, and when she revealed that the voice had been recounting our every movement over the last three days I suddenly grasped the true significance of her words. I reached over and lifted the journal out of its sling, before swiftly turning to the back page and finding the Amulet gone.

Certain by now that we had a traitor in our midst, I rushed out of the tent and woke two of the most dependable guards. Together we stormed Archemon's tent and found him sitting cross-legged with the Amulet hovering in front of him, its concentric rings revolving about themselves while the central stone glowed brightly. He appeared not even to notice our dramatic entrance, continuing instead with his detailed account of the dragon's violent death earlier in the day.

His report was delivered in a dull, impassive monotone but as he spoke not once did his lips move, and he undoubtedly would have continued thus had he not been roughly assailed by one of the guards. As the trance broke he suddenly started, as if waking from a deep sleep, and at the same moment the Amulet snapped shut with a brilliant flash, before dropping to the ground. The guards dragged him outside and when I stooped to pick up the Amulet I noticed a piece of parchment lying nearby, which upon closer examination confirmed my gravest suspicions.

Written in a spidery hand that I instantly recognised as that of Ganzicus, the page consisted of notes and diagrams, which, if carefully followed, would enable even a layman to avail himself of the Amulet's most basic function, this being the conveyance of telepathic communications. Whether Ganzicus had promised the Captain great wealth for acting as his spy or whether dark magic had been employed to secure his loyalty I could not determine, but this morning Archemon was subjected to a rigorous interrogation which revealed much about his master's plans.

As the Captain gradually gave up his secrets I began to realise just how seriously I had underestimated Ganzicus, not just in terms of his desire for vengeance but also for his overwhelming determination to return to the seat of power. Naively perhaps, I had originally thought that the 'turning' of the dragons was merely an act of defiance – a means of spiting the ailing King and preventing him from going peacefully to his grave. It now seemed that his true motives were far darker than any of us could have imagined. Under considerable duress from the guards, Archemon explained that the aggressive behaviour of the dragons under Ganzicus's influence was simply a diversion, designed to draw me away from the Palace on a long and difficult mission at the time when the King himself was growing weak. Clearly his intentions were to return to the Palace in my absence and seize the power that he considered rightfully his. I will probably never know what led Ganzicus into the ways of darkness all those years ago but I find it hard to attribute his corruption to a simple matter of jealousy.

I strongly suspect that he somehow made contact with the Dark Dragon of Demonica and was unable to resist the lure of its power. The spirit of Demonica is pure evil and had it been raised by Ganzicus, whether deliberately or accidentally, it would have inexorably poisoned his soul. Such conjecture is pointless now, however, for although Ganzicus may well have grown very powerful during his years in exile, we cannot countenance the idea of returning to confront him until our tasks are completed. We have many battles yet to fight.

Carefully, we began our descent of the canyon wall, retracing the steps we'd taken in recent days. Flanked by two guards and with hands tied, Archemon trailed behind us with his head bowed low in shame. As I walked, my thoughts returned to the previous night and Amaleh's visit to my tent. So intent had I been on understanding her urgent message that the significance of her precise words had since slipped my mind. If she had indeed felt the Captain's voice rather than heard it then there could be no doubt that she had the gift. With appropriate guidance and tuition she had the potential to become a great Sorceress.
Suddenly my reverie was shaken by a shout from the back of the group. Turning swiftly, I was just in time to see Captain Archemon sprint across the path and leap to certain death. Perhaps understandably, the guards made only a token attempt to stop him.

We reached the canyon floor soon after sunrise this morning and I immediately despatched a small team to gather specimens from the dragon's carcass. They rejoined us several hours later, bringing with them a number of interesting samples which I deemed worthy of inclusion in the book. On the way back they had also passed the mutilated corpse of Captain Archemon, his clothes largely stripped from him by the appalling fall. Despite his injuries, they noted a strange symbol which had appeared on the Captain's bare chest and made a quick sketch of it to show me upon their return.

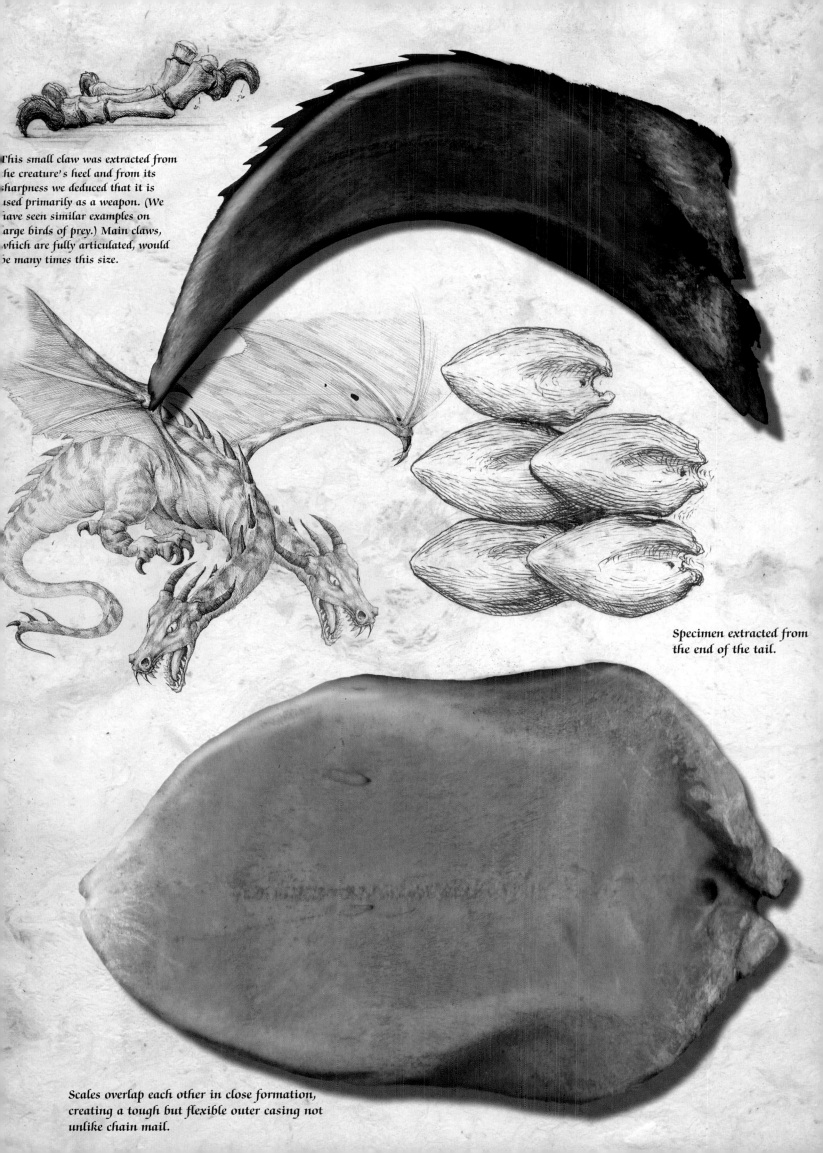

This small claw was extracted from the creature's heel and from its sharpness we deduced that it is used primarily as a weapon. (We have seen similar examples on large birds of prey.) Main claws, which are fully articulated, would be many times this size.

Specimen extracted from the end of the tail.

Scales overlap each other in close formation, creating a tough but flexible outer casing not unlike chain mail.

I had never seen its like before but the motif strongly suggested to me that the Captain had indeed fallen prey to the powers of dark magic and that this was Ganzicus's way of marking his man.

Day Sixteen

It has taken just two days to journey all the way back to the port of Tremana and we found ourselves feted upon our return. The townspeople had re-stocked the vessels during our absence, adding many gifts of their own in an effort to make the next stage of our voyage as comfortable as possible.
We set sail early the next day, immediately heading towards a complex archipelago that would lead us to the Southern Kingdom.

Chapter Five

The Voyage South

Day Nineteen

This afternoon I felt that the time was right to speak to Bandred about what had happened in the canyon and the conversation turned in due course to the responsibilities he would ultimately have to face as the future King. I praised him for the bravery he had displayed on the high pass just a couple of days ago and conceded that we probably would have missed our best chance had he not revealed himself to the beast at that point, but I had also to admonish him for his recklessness. I explained that a Sovereign must never endanger himself so and he accepted my warning with good grace.

Day Twenty-one

Our course through these islands has been plotted by our chief navigator and its complexity is dictated by the need to avoid the treacherous currents for which these waters are noted.

This evening, as we passed though a narrow channel between two jagged peaks, the night sky was briefly illuminated by a flash of orange light. The lookout summoned me to the main deck and together we awaited a repetition of this strange phenomenon. Several minutes passed before it happened again but this time there could be no mistaking the two giant tongues of flame which roared out of the darkness towards us. Clearly visible behind them, high up in the mountains, was a dragon of immense size. Our vessels had just passed under a rocky causeway when the jets of fire came again, shattering the bridge into hundreds of superheated boulders which threw off great plumes of steam as they plunged into the icy waters behind us.

It's quite possible that the commotion caused by the collapse of the causeway led the creature to believe it had found its target for it made no further attacks on our ships last night.

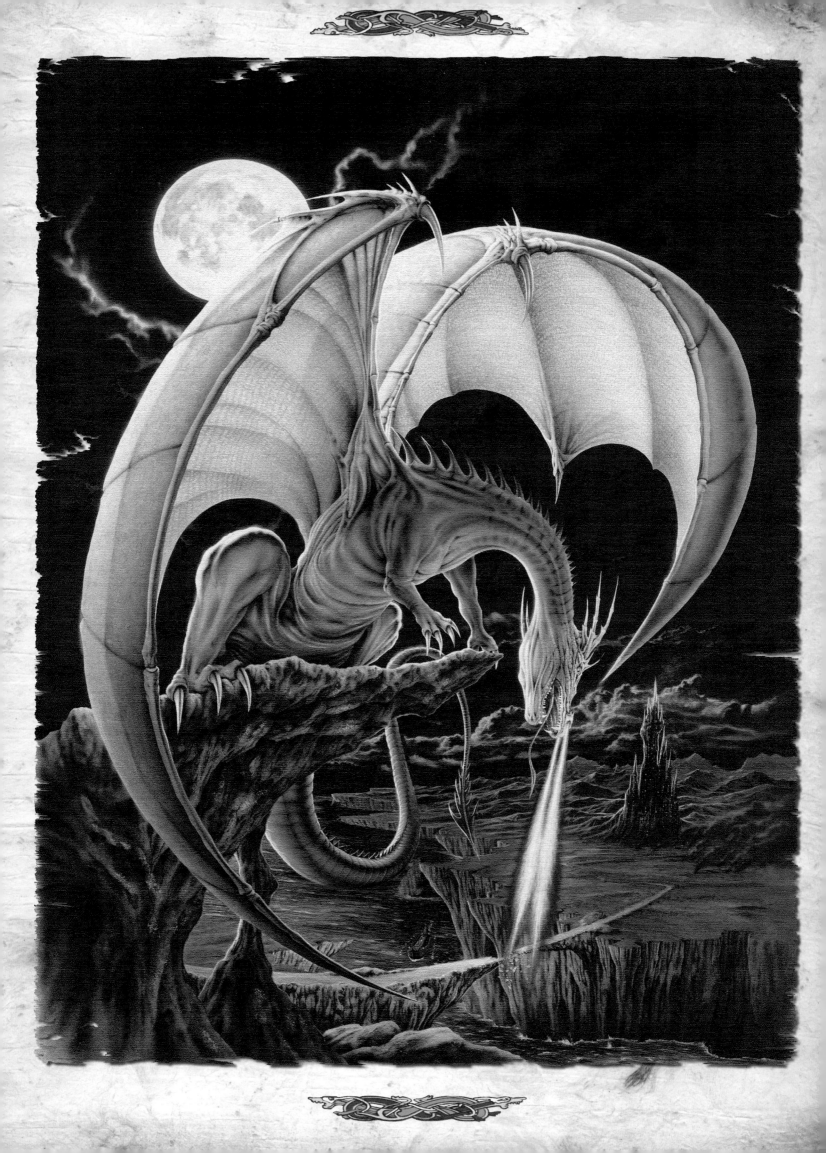

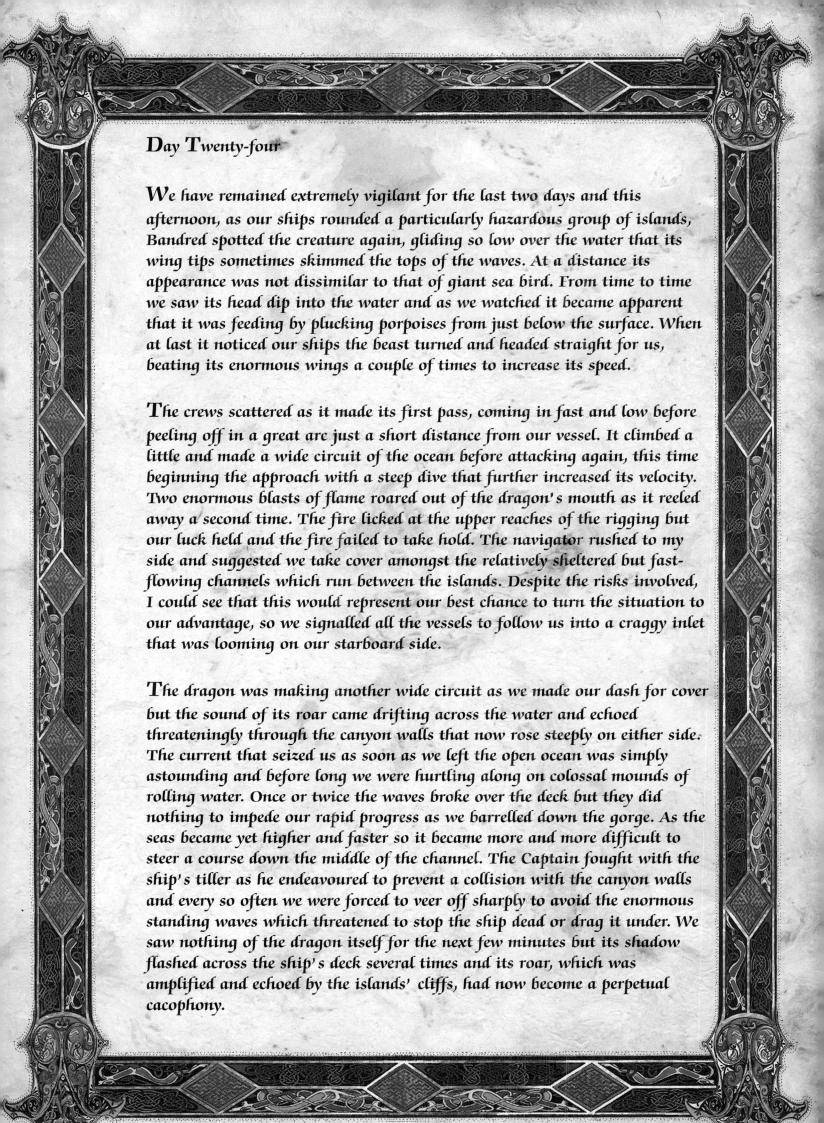

Day Twenty-four

We have remained extremely vigilant for the last two days and this afternoon, as our ships rounded a particularly hazardous group of islands, Bandred spotted the creature again, gliding so low over the water that its wing tips sometimes skimmed the tops of the waves. At a distance its appearance was not dissimilar to that of giant sea bird. From time to time we saw its head dip into the water and as we watched it became apparent that it was feeding by plucking porpoises from just below the surface. When at last it noticed our ships the beast turned and headed straight for us, beating its enormous wings a couple of times to increase its speed.

The crews scattered as it made its first pass, coming in fast and low before peeling off in a great arc just a short distance from our vessel. It climbed a little and made a wide circuit of the ocean before attacking again, this time beginning the approach with a steep dive that further increased its velocity. Two enormous blasts of flame roared out of the dragon's mouth as it reeled away a second time. The fire licked at the upper reaches of the rigging but our luck held and the fire failed to take hold. The navigator rushed to my side and suggested we take cover amongst the relatively sheltered but fast-flowing channels which run between the islands. Despite the risks involved, I could see that this would represent our best chance to turn the situation to our advantage, so we signalled all the vessels to follow us into a craggy inlet that was looming on our starboard side.

The dragon was making another wide circuit as we made our dash for cover but the sound of its roar came drifting across the water and echoed threateningly through the canyon walls that now rose steeply on either side. The current that seized us as soon as we left the open ocean was simply astounding and before long we were hurtling along on colossal mounds of rolling water. Once or twice the waves broke over the deck but they did nothing to impede our rapid progress as we barrelled down the gorge. As the seas became yet higher and faster so it became more and more difficult to steer a course down the middle of the channel. The Captain fought with the ship's tiller as he endeavoured to prevent a collision with the canyon walls and every so often we were forced to veer off sharply to avoid the enormous standing waves which threatened to stop the ship dead or drag it under. We saw nothing of the dragon itself for the next few minutes but its shadow flashed across the ship's deck several times and its roar, which was amplified and echoed by the islands' cliffs, had now become a perpetual cacophony.

Without warning the ship entered an especially turbulent patch of water and immediately began a slow rotation. Our Captain was powerless to prevent this disastrous manoeuvre and we soon found ourselves at the mercy of the huge waves that came thundering into the side of the ship, but under the relentless force of the current the spin continued and a few moments later we were facing forwards again, moving faster than ever.

Suddenly I was thrown violently to the deck. Our ship had plunged into a deep trough of churning water and our passage through the canyon had come to a shuddering halt. So vast was this inverted wave that it swallowed the entire ship, holding her fast in a precarious position and exerting tremendous force on her timber frame, which groaned under the strain.

As the tumultuous waters surged past on either side of us the ship's crew struggled to maintain their positions on the badly sloping deck. The first of the other vessels hurtled past us, closely shadowed by the dragon itself. Her crew were so busy trying to deal with the various fires that had broken out on deck that they barely even noticed our dire predicament, and were therefore unable to assist us in any way. We were momentarily awestruck by the sheer size of the beast as it flew low overhead, its great wings almost spanning the width of the gorge.

I knew that we might never escape our fate but at least we had at our disposal the means to injure this terrible beast and possibly even slay it. Alone amongst the various ships, ours has a large deck-mounted ballister, which, though difficult to arm, is extremely powerful. The only advantage afforded by the incline of the ship's deck was that the ballister was pointing skywards, perfectly positioned to repel an attack from the air. Struggling to make myself heard above the rush of the water, I ordered the crew to make ready the weapon by filling the huge pan at the end of its lever arm with a sackload of spiked iron balls. Several minutes passed before they had completed their task. Our Captain climbed to the top of our main mast and reported that one of our vessels appeared to be stuck fast on a rocky outcrop further up the channel. From what he could see, the dragon was making repeated attacks on their ship but was hampered by the confines of the canyon walls.

Eventually it gave up its assault on the others and turned its attention to us, presumably considering our vessel to be an easier target. To his credit, our Captain remained at the top of the mast as the monster bore down on us, readying himself to give the signal to fire. When his arm came down the dragon still couldn't be seen by those of us on deck but the crew trusted his judgement and the catapult was duly fired, propelling its deadly hail high into the air.

At exactly the same moment, the dragon appeared above the ship, moving very fast and virtually filling the sky above us with its enormous bulk. Some of the missiles went astray but a great many collided with the creature's underbelly, embedding themselves in the flesh or opening up bloody gashes in the skin's surface where they had caught only a glancing blow. Some of the spiked balls punched straight through the wing membrane, leaving ragged holes which were almost certain to affect the dragon's stability in flight. An agonising shriek escaped its mouth as it banked away sharply and disappeared from view. Our desperation ensured that feelings of triumph were far from our minds but as the Captain came climbing down through the rigging I could see from his face that he had not given up hope of escape. Hurriedly, he explained that the other vessel had now drifted free of the rock and would be passing us very soon. If we could get a line to it and their crew could secure it swiftly enough there was just a chance that the momentum of the other ship would haul us clear. The captain seized a crossbow from the armoury and quickly tied a length of twine to the arrow's shaft, just ahead of the flights. As he again ascended the rigging, weapon in hand, I tied the other end of the twine to the strongest piece of rope I could find on deck, hoping that there would be sufficient length in its coils to reach the other vessel. Even as I completed the knot it was ripped violently from my hands. The Captain had fired the crossbow and from his exultant cries I guessed that the arrow had found its target. Unable to see what was happening above our line of sight, those of us on deck could only watch and wait as the rope swiftly ran out. A heavy iron cleat, to which the rope was attached, was all that remained once the coils were gone and as the rope snapped taut the bolts that attached the cleat to the deck shifted visibly in their mountings.

For a second I thought they would give way but instead it was the ship's railing that collapsed, crushed by the tremendous tension in the rope. At first our ship rolled to one side alarmingly but then, in a heaving action which felt as if she were tearing apart, she broke free of the standing wave and was carried swiftly back into the main current. Just a short distance further on the channel widened a little and the waters calmed before delivering us to the open ocean once again, where we found the other ships waiting. Amazingly, there was no loss of life as a result of this encounter but several warriors sustained burns and the damage to one of the vessels was considerable.

Day Twenty-eight

The last three days have passed without further incident but my sense of unease returned as we made landfall in the South Kingdom tonight. Our plan was to spend a night of relative comfort at nearby Ursicus Castle but soon after we began unloading the ships it became apparent that we were in grave danger.

The dragon that had stalked us since we left Tremana appeared again, perching on a clifftop high above the bay and belching fiery threats which lit up the landscape around us. There was no time to ready any of the heavy weaponry, so a few light arms were snatched from the ship's armoury and we took cover where we could. Visibly scarred by the injuries our catapult had inflicted earlier in the week and perhaps a little more cautious than before, the dragon waited several minutes before mounting its attack. Instead of launching itself into mid-air as we'd expected, the creature simply slid off the ridge, dislodging what appeared to be its nest as it did so. Two huge eggs tumbled out and exploded on the rocks below while the monster itself half flew and half scrambled down the mountainside, dragging one of its wings awkwardly behind it. We now knew that we had severely disabled the creature but this thought provided little comfort as, screaming furiously, it fought its way across a rocky escarpment towards us. Some of our party panicked and fled, hoping to out-pace the dragon in a frantic dash across open grassland to the security of the castle.

Although unable to fly, the creature was putting its good wing to effective use with great thrashing movements and these powerful downstrokes enabled it to spring forward in gigantic bounds. On landing, its talons would lock firmly into the ravines that criss-crossed the escarpment and it would stabilise itself briefly before the next strenuous leap. In the event, it was these narrow gullies, most of them no wider than a man's body, that not only provided shelter for those who remained but also gave me my one opportunity to slay the beast.

I left Bandred and Amaleh where they hid and after instructing nearby warriors to shield them as best they could I picked up a crossbow and clambered out onto the escarpment. The dragon had stopped a little way off and was driving its snout forcefully into one of the ravines in an effort to get at those who sheltered within but on seeing me emerge from hiding it snarled viciously, spat a ball of flame high into the air and took a great leap in my direction. As it approached I threw myself into another of the rock fissures and lay there with crossbow poised, waiting for the huge head to appear above me. Slowly it came into view and a second later the jaws were upon me, crashing against the narrow opening of the ravine with astounding force. Try as it might, the creature simply couldn't force its huge snout far enough into the gully to reach me and the frustration was driving it into a fury. So frenzied was the attack that its teeth splintered on the surrounding rocks and its gums tore open, spilling cold, black blood onto my face. With its rough tongue it probed the inner recesses of the ravine but the slavering form never quite gained sufficient purchase to lever my body out of the hole. The blasts of hot, damp air that issued from the monster's nostrils reeked of death itself but I was merely thankful for the fact that it hadn't occurred to the beast to spit fireballs into the fissure.

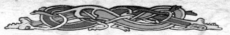
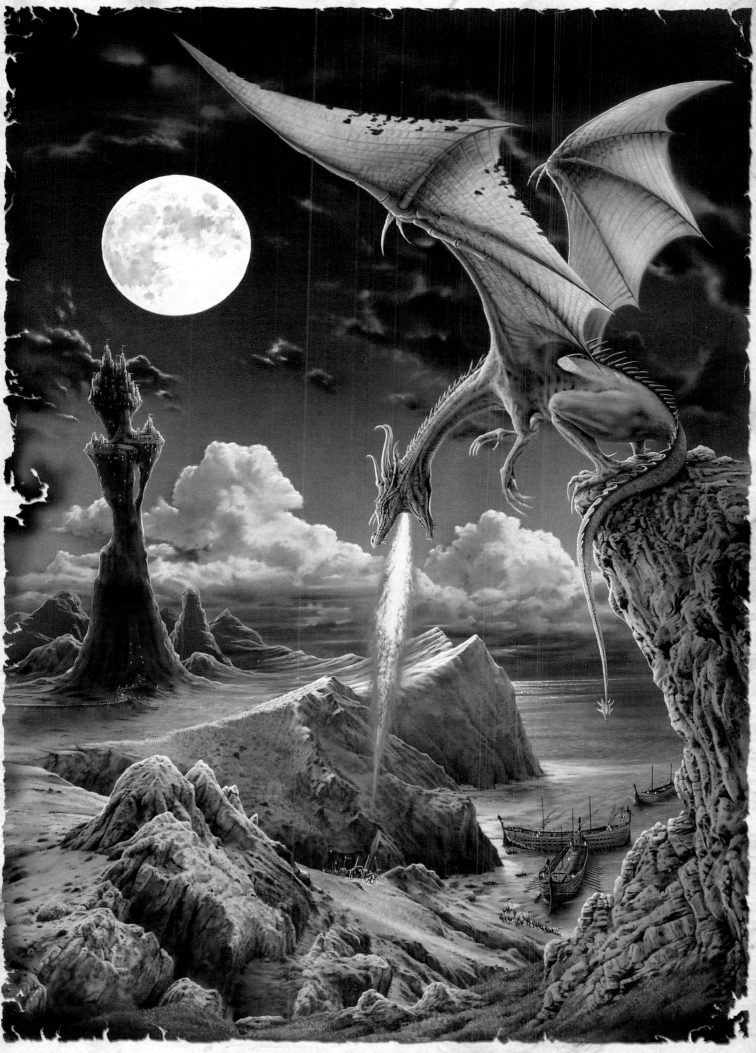

Twice more the head lunged forwards before I had the angle I needed but when at last I had a clear view up into the roof of the creature's mouth I fired the bolt. The effect was so sudden and dramatic that there could be no doubt – the bolt had penetrated the underside of the brain, resulting in instant death. The huge body slumped to the ground, trapping me in the ravine and it was only when some of the warriors had cut away part of the carcass that I was able to climb out.

Exhausted, we decided to delay further unloading of the vessels until tomorrow morning and went straight to the castle, where a celebratory feast of dragon steaks was enjoyed.

Chapter Six

Prophecy of Evil

Day Twenty-nine

On waking this morning I went immediately to the large window in the corner of my room. There had been a heavy rainstorm during the night but the clouds had largely blown over and as I surveyed the dramatic coastline the sun began its steady ascent from the horizon. In the middle distance the dead dragon lay splayed on the rocks, its scale still surprising to the eye when set against the landscape around it. As I watched, numerous scavengers came to feed on the carcass. Seabirds first, closely followed by wolves, wild boar, and other animals. Beyond this, our ships at anchor in the bay and to the right, on the lower slopes, some pale, jagged forms which I did not at first recognise. Then I remembered the dragon's nest which had fallen from the top of the cliff and the eggs which had been dashed on the rocks.

Shortly after breakfast I gathered a small team and whilst everyone else continued unloading the ships in preparation for the next stage of the journey, I took my group to the site of the fallen nest. The parts of it that were still intact revealed a construction of some intricacy and I had our artists make some sketches at the scene. Perhaps most impressive was the way in which thick tree trunks had been twisted and contorted to build the nest and we could only marvel at the strength and dexterity required to distort them so. A short distance away we found the first of the shell fragments and beyond that, the carcasses of two embryonic creatures, which allowed us to make certain observations about the gestation of this particular breed. The shells themselves were much thinner than we'd expected and looked extremely brittle but when we attempted to break off a few samples for inclusion in the book we found them to be immensely strong and it was only by pounding the outer casing with boulders that we were able to obtain the specimens we wanted.

By the time we'd finished making our notes just about all the equipment and provisions had been removed from the ships. I made my way across to a high point on the coastline from where Bandred seemed to be controlling the proceedings and, with a kindly smile, reminded him that he is not in command even during the periods when I am temporarily absent. We both laughed and the manner in which his eyes creased up strongly reminded me of his father when he was young. It amused us both that everyone seemed to be taking his orders, even if they were indulging him a little, and I was secretly pleased to see how easily he had assumed the leadership qualities that were soon to become an integral part of his forthcoming role as Sovereign Ruler of the Four Kingdoms.

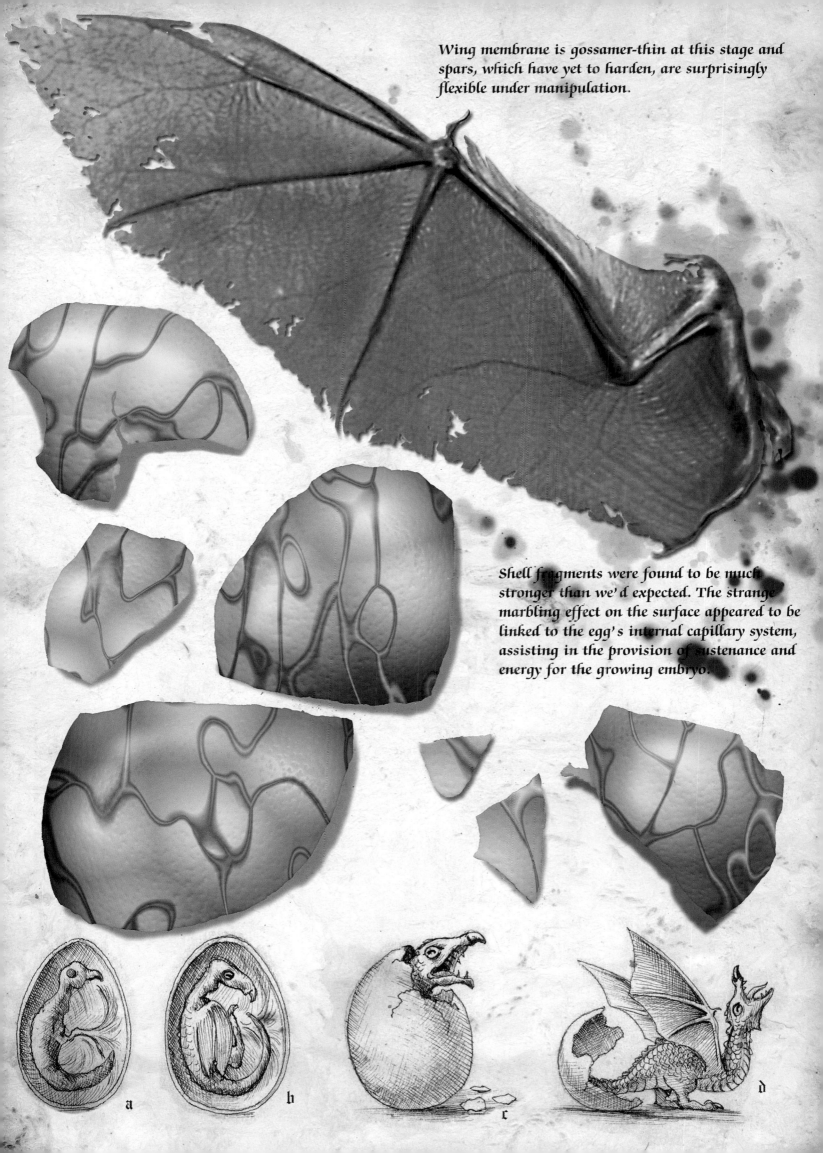

Wing membrane is gossamer-thin at this stage and spars, which have yet to harden, are surprisingly flexible under manipulation.

Shell fragments were found to be much stronger than we'd expected. The strange marbling effect on the surface appeared to be linked to the egg's internal capillary system, assisting in the provision of sustenance and energy for the growing embryo.

a

b

c

d

It was difficult to leave the comfort of Castle Ursicus but our journey is far from over and I knew that if we stayed another night it would be even harder to move on. I therefore insisted that we set out for the Lost Valley of Skernia immediately. According to reports, the infamous Dragon of Kargan had recently taken up residence there.

By late afternoon the undulating hills had given way to a hard sun-baked plain. Progress would have been easy except that gaping cracks had opened up in the surface and, whilst men and horses could jump them with ease, the heavy weapons had to be painstakingly wheeled across on wooden planks. In the far distance we could see our objective, the Vorgamon Mountains, and rising high out of their midst the two snowy peaks that marked the entrance to the Lost Valley itself.

Day Thirty-two

The journey across the plain has been harder than any of us anticipated, our discomfort exacerbated by the relentless sun and the complete absence of shade. After two days many of our group are close to exhaustion and one of the warriors has grown delirious with the heat. I realise I must do something, but what I dare not reveal to those around me is that I myself am growing weak. The inner fire has been ebbing away for some time now and, whilst my powers are still considerable, I can no longer exercise them without draining my strength. Tonight, as everyone lay sleeping in their tents, I took from the trunk a group of Runic tablets and a page from the Book of Serafan. After setting up the correct configuration I placed my palms on the two tablets nearest to me and began the incantation. It was fully thirty minutes before the first thunderclap came, heralding the blanket of storm clouds which would shield us from the searing heat of the sun until we made it to the shelter of the mountains.

Manipulation of the weather patterns is not something I do lightly for it takes a vast amount of energy and disturbs the natural order of things. In circumstances such as these, however, one must take such steps simply in order to survive. Under the protection of cloud cover we journeyed across the plain for two more days, the mountains looming yet larger on the horizon with each passing hour.

Day Thirty-four

Last night, as I lay in my tent, I experienced a vision of unusual clarity. Sleep had eluded me and my mind had once again turned to Ganzicus when a vivid scene appeared before my eyes. It was Ganzicus himself, standing on one of the observation decks at the King's palace. On his arm there perched a small dragon, and as the creature's head snaked menacingly back and forth Ganzicus stared straight ahead, as if surveying the Kingdom below. Slowly he turned towards me and smiled, before thrusting his arm skywards and launching the dragon into the air.

Such visions are uncommon but I have come to regard them as a window on another time and place. Unfortunately it was impossible to tell whether Ganzicus was already ensconced in the palace or whether the vision represented a prophecy of some kind but, either way, it was a powerful confirmation of his intentions. The scene dissolved before my eyes when I heard Amaleh's voice outside the tent.
'Septimus,' she cried, 'I've just had a strange dream – I saw an evil-looking man holding a dragon.'

Bringing her quickly inside, I produced a sketch of the scene that had come into my mind and she immediately identified it as a mirror of her own vision. I then told her about Ganzicus, after which she enquired, quite reasonably, about her ability to see and hear things that others do not. The hour was late but I felt that she was owed an explanation and so I began to tell her about the gift. I also promised her that, should I survive the mission, I would educate her in the ways of wizardry and bring her innate talents to fruition. As she left my tent in the dead of night, my gaze again fell upon the sketch of Ganzicus I'd done and, having had its significance confirmed, I resolved to have one of the artists render it in colour the following morning.

Day Thirty-five

As dawn broke this morning I again took Amaleh to one side and reminded her that she should not speak to anyone of her gift, least of all Bandred, who would undoubtedly be somewhat envious of her powers. She promised to keep our secret and added, rather touchingly, that she thought Bandred would make an excellent King. I agreed with her and we set off for the foothills of the Vorgamon Mountains, now only a short distance away.

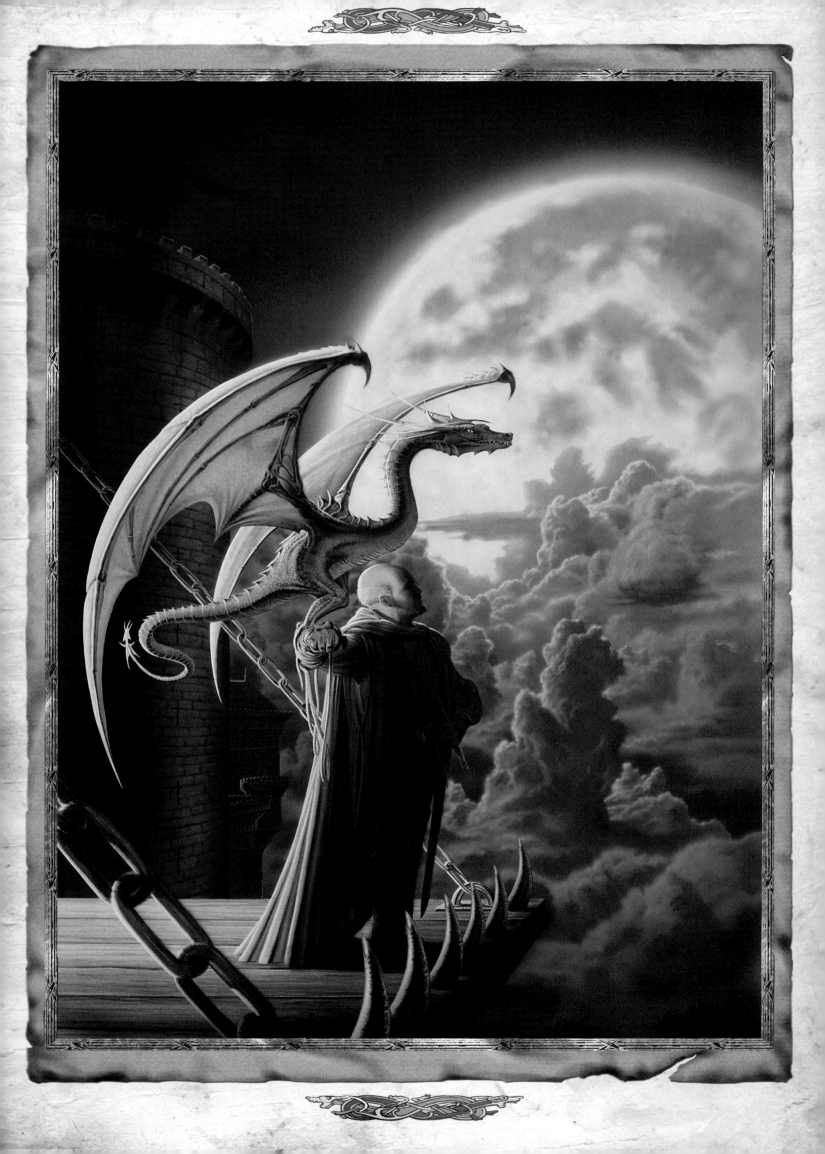

On reaching the lower slopes we sought out a grassy bank on which to rest but our break was rudely interrupted when one of the warriors reached into a sack of cured meats and was badly bitten by a stray dragonet which had secreted itself there. The creature, which had presumably travelled with us since we were attacked by the swarm, had grown fat on our supplies and could barely haul itself into the air but it was still vicious enough to pose a considerable threat. Several warriors picked up their swords and attempted to spear the dragonet as it thrashed about on the ground spitting and snarling, and were it not for the deadly sting in the creature's tail they probably would have got closer and despatched it more efficiently. As it was, several minutes passed before they were able to ensnare it in a net and put it to death, crushing it underfoot with evident satisfaction.

As we continued up the ever-steepening path into the mountains I took the opportunity to speak to Bandred about his father. The vision of Ganzicus at the palace had forced me to accept the fact that the King may already be dead and I felt that I had a duty to warn Bandred of what we might find when we eventually returned home. The boy surprised me by saying that he'd already given a lot of thought to his father's illness and even appeared to accept the inevitably of his death but, despite this show of maturity, I could not quite bring myself to reveal just how powerful Ganzicus had become or what a formidable opponent he was likely to prove.

Day Thirty-six

As we climb ever higher the path grows more and more treacherous and there were several occasions today when we contemplated leaving some of the heavier equipment behind. After rounding yet another hazardous bend we were confronted by a tall opening in the face of the mountain. The track disappeared into the darkness of the tunnel and on either side the entrance was flanked by two immense stone columns which had been laboriously hewn from the rock itself. I immediately recognised it as the Kror Passage, created many thousands of years ago to bypass the more precipitous sections of the mountain and allow access to the Lost Valley beyond.

We lit the torches and, with some trepidation, proceeded on our way. The track was even steeper inside the tunnel and dangerously uneven, but perhaps most unnerving of all were the glowing eyes which stared back at us out of the darkness – small creatures of unimaginable shape and form which probably never even saw the light of day.

We were about half way through when disaster struck. Towed by a team of six horses and accompanied by a small group of warriors, the Madagan crossbow, one of the largest weapons in our arsenal, was leading the way through the tunnel. The panic-stricken shouts that rang out in the dark were the only warning we had that its coupling had broken under the strain and that it was hurtling back down the passage. Although the tunnel was quite wide at this point there was nowhere we could shelter with confidence because the crossbow was swerving violently from one side to the other, crashing off the walls. With each of these collisions came the grinding of the metal wheel hubs against bare rock and a spectacular shower of sparks. Only once did the sparks fail to appear and this, I understood later, was because a hapless warrior had been crushed between the wheels and the tunnel wall. The rest of us managed to save ourselves by waiting until the crossbow was almost upon us and leaping aside at the last possible moment. We watched helplessly as it thundered past, gathering even greater speed before rocketing out of the tunnel's entrance and bursting through the low stone wall that bounded the outside edge of the track. It was several seconds before an almighty crash echoed up through the valley, confirming that the crossbow had smashed itself to pieces on the rocks far below. There was nothing to be done, so we simply had to hope that we could manage without it. Following this incident, it was with some relief that we emerged into daylight at the top of the tunnel a little later. The track led across to a stone bridge which spanned a narrow but extremely deep chasm. The bridge itself was barely wide enough to be passable but one by one it delivered us safely to the other side and thence to the valley's entrance, which was marked by two giant stone gargoyles.

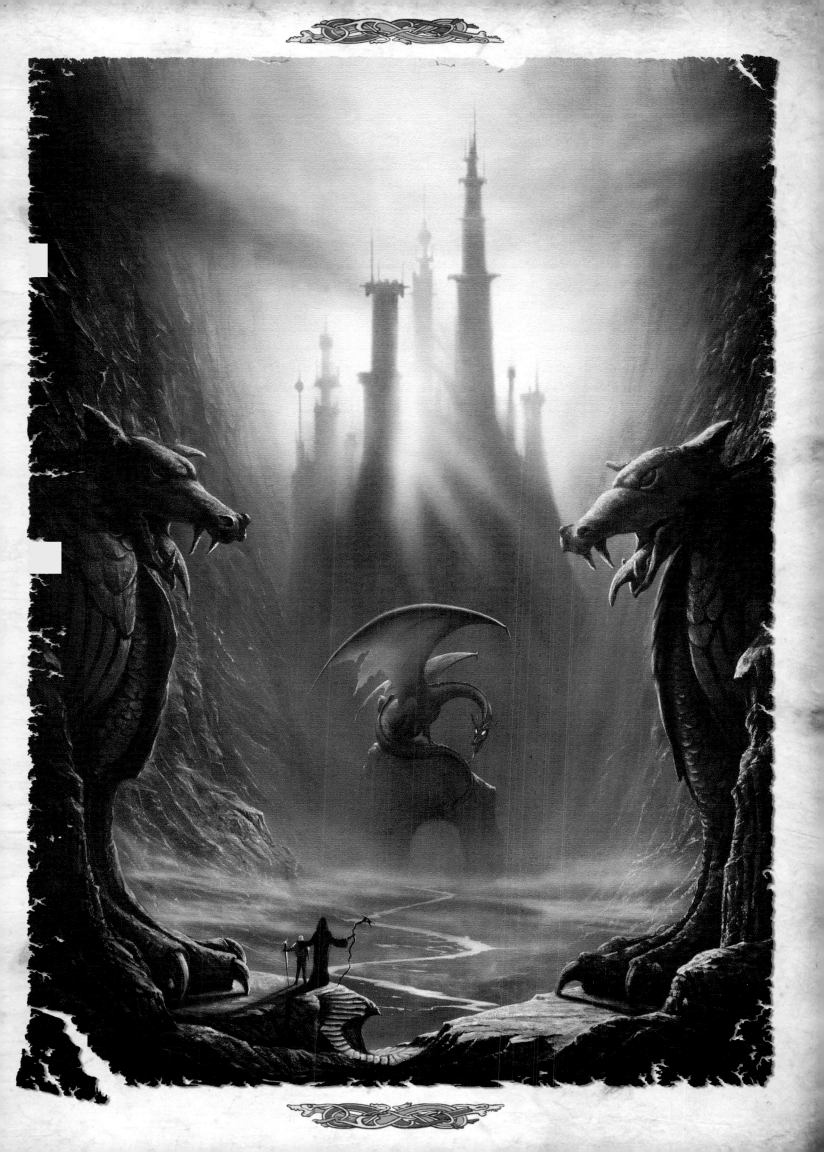

Before beginning our descent into the valley, I took Bandred up a short flight of steps to a small plateau, which provided a spectacular view of the castle at the head of the gorge. As we watched, the mists cleared a little to reveal a large stone arch on the valley floor and then, slowly at first, the top of the arch began to move. For a moment I was mystified by this sight but it soon became apparent that we were witnessing a dragon unfurling its wings. Bandred began to shake with fear but I reassured him that I knew of no dragon that would be able to detect the presence of humans at this range. He seemed doubtful but once we'd rejoined the others on the main track he relaxed a little. The downward incline was quite steep here but the path was much smoother than those we'd become accustomed to and it didn't take us more than a few hours to reach the flood plain at the foot of the valley walls.

Chapter Seven

◆

Into the Caves

Day Thirty-eight

Fortunately, the plain itself was strewn with huge boulders which enabled us to remain largely hidden from view as we slowly worked our way towards the arch. We had learned from the peasants we had passed on our journey that this dragon had been responsible for a great many deaths over the last few months and it has apparently made the Lost Valley its home after driving out the inhabitants of a number of small hamlets which cling to the rocks around the foot of the castle. I know the Skernians to be a quiet, peace-loving people and it pains me to contemplate the suffering they have experienced as a result of their brutal exile. According to the reports we had heard, a small group of them had become trapped on a remote ledge as they had attempted to flee and had been savagely picked off one by one. Rumours abounded that the creature's tail was lined with a series of small barbs which secreted an acid of some kind and if this was true we would have to exercise extreme caution in any plan of attack.

Day Thirty-nine

As we drew nearer to the arch I became fearful for our chances. Our weapons are now much fewer in number and the beast looked truly formidable now that we could see it at close quarters. Perhaps scenting us in the air, the creature slowly drew itself up to its full height and the tail, which was indeed covered in tiny spikes, dragged across the rock face leaving a smouldering trail of yellow liquid.

We decided to delay engaging the creature in battle whilst we considered our limited options. Ahead of us, hidden from the dragon's line of sight, was a large cave which would provide cover for the night but as we approached the entrance we were somewhat surprised to be greeted by a rather dishevelled band of individuals who identified themselves as Skernians. They confirmed that many of their number had been taken by the beast as they had fled their homes and explained how they had survived in the cave for so long, too terrified to attempt an escape.

Tonight, I called a meeting of the various group Captains and invited the Skernians to attend in the hope that they might be able to provide more detailed information about the dragon's behaviour. As they talked, it transpired that the creature's strengths were many and its weaknesses few. Of particular concern to my advisers was this dragon's habit of lashing out with its deadly tail and thereby preventing any would-be assailant from getting close enough to inflict serious harm.

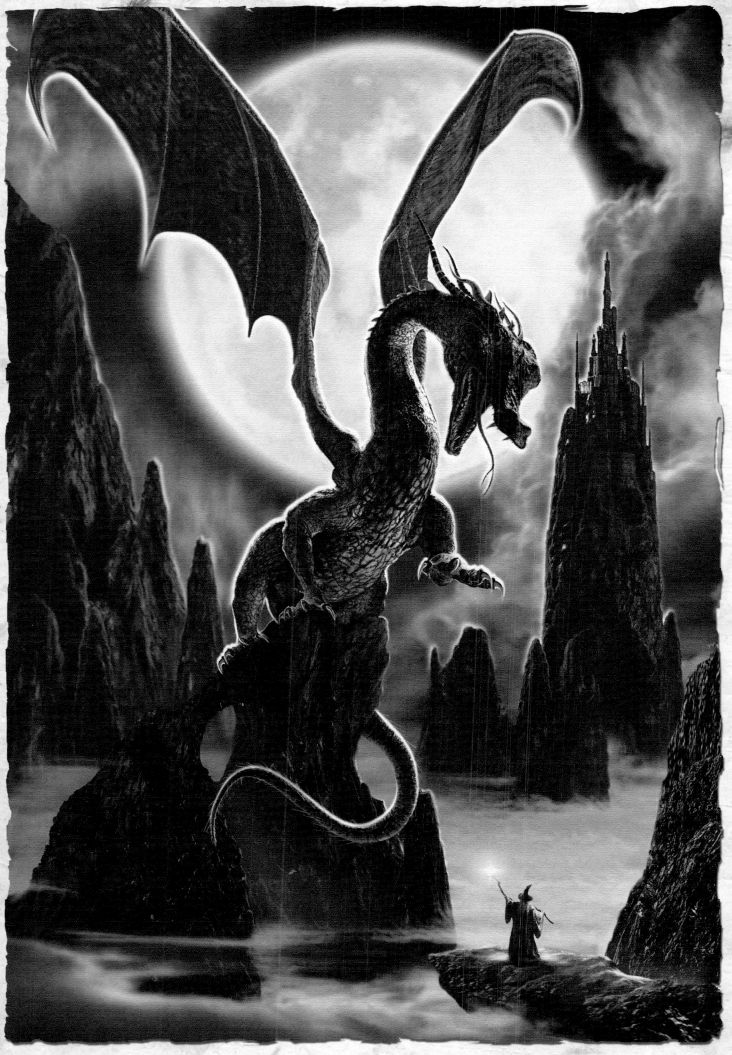

As I lay in my bed tonight I could not escape the conclusion that I would have to draw deeply on my inner reserves and attempt to slay this monster myself, for any form of conventional approach would almost certainly result in huge loss of life.

Day Forty

Early this morning I took from my trunk an ancient tome which has long been one of my most treasured possessions. Many of the ceremonies contained within are powerful and complex but demand great strength on the part of the practitioner. I knew of a spell that had the potential to bring down a large animal but if I increased its potency to the point where it could have the same effect on a creature this size the effort required to channel the energy might very well kill me. Knowing this, and having to make provision for the possibility of the mission's continuing without me, I had no choice but to take Bandred and Amaleh into my confidence. As I'd expected, they were both very upset at first and begged me to think of an alternative but after I'd explained the vulnerability of our position they reluctantly came to accept my chosen course of action as the only viable option. We slipped quietly away from the group and made our way down to a spur of rock from where we had a clear view of the creature and I bade them hide as I set the open book down on the ground in front of me. The incantation associated with this spell was particularly long and as I neared its completion the crystal orb at the tip of my staff began to glow brightly. It must have caught the dragon's eye for the monster again began to rouse itself as if preparing to attack.

More than this I cannot recall, save for a blinding flash of light, but reports given to me later on by Bandred and Amaleh described a tremendous blast of white fire which issued from the orb and struck the dragon in the eye, apparently killing it instantly.

I must have remained in a coma for several hours because the first thing I saw when I regained consciousness was a team who were just returning from the carcass bearing various samples for the book. Notable amongst these were the barbs they'd extracted from the creature's tail but since they were still smeared with acid we had to handle them with great care.

I had evidently completed the ceremony and my body had somehow survived the ordeal of serving as a conduit for the phenomenal forces involved but what followed were recriminations rather than thanks. If it were possible to slay a dragon of such magnitude using magic alone, the warriors reasoned, why had I not made more frequent use of my powers during the earlier encounters? Still I dared not tell them how weak I have become, for I know how badly it will affect their morale if they learn the truth.

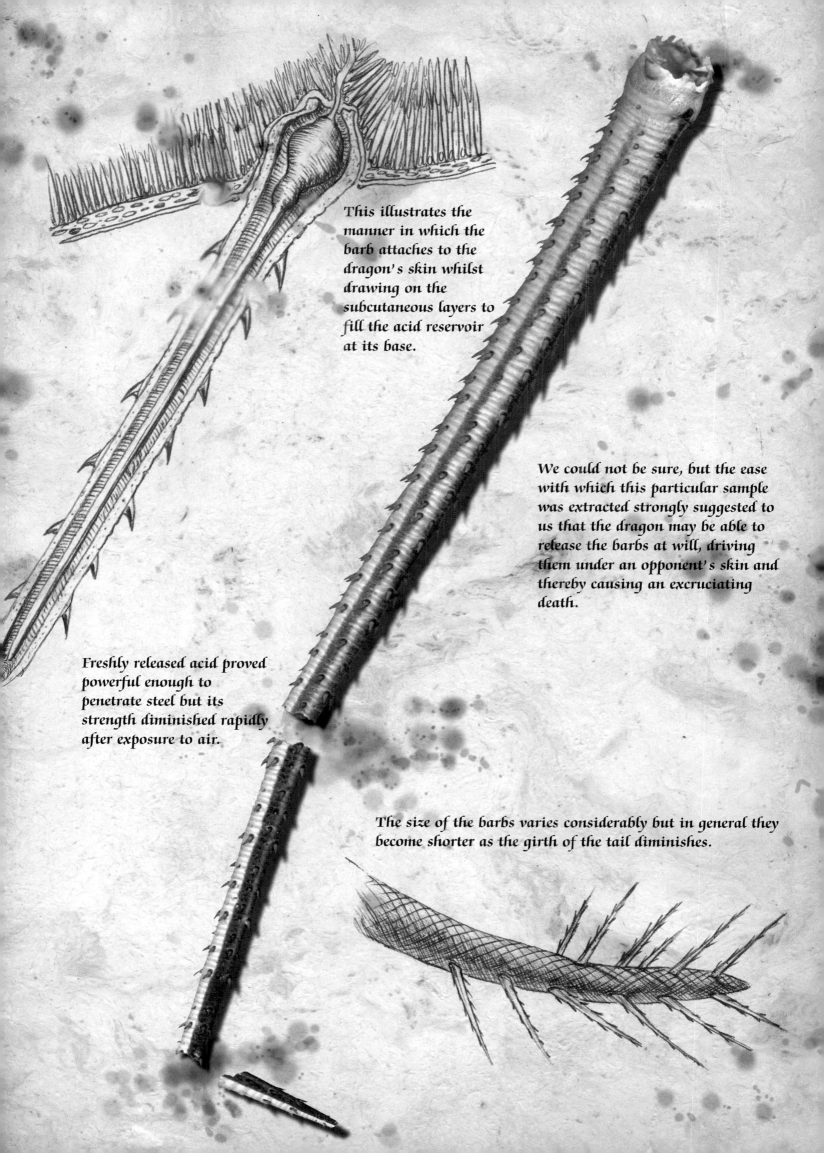

This illustrates the manner in which the barb attaches to the dragon's skin whilst drawing on the subcutaneous layers to fill the acid reservoir at its base.

We could not be sure, but the ease with which this particular sample was extracted strongly suggested to us that the dragon may be able to release the barbs at will, driving them under an opponent's skin and thereby causing an excruciating death.

Freshly released acid proved powerful enough to penetrate steel but its strength diminished rapidly after exposure to air.

The size of the barbs varies considerably but in general they become shorter as the girth of the tail diminishes.

Day Forty-one

This afternoon, as we travelled on past the great arch, I noticed that Bandred had his arm around Amaleh and it gave me cause to wonder whether their bond had developed beyond friendship. The resilience of their spirit, in spite of all the perils we'd faced and those yet to come, was an inspiration to me. Under my breath I wished them well, but continued to hope that Amaleh would not reveal her secret to the future King, at least for now.

Despite the injuries and loss of life we've sustained so far, when I reflect on the mission and the odds stacked against us I consider that fortune has smiled upon our ragged band. If we can continue thus we will be able to count the mission a success but, after everything, we will almost certainly have to face Ganzicus himself in a showdown at the King's palace. This is indeed a grim prospect, for we will all be physically and mentally exhausted by the time we eventually return home. I must not dwell on such thoughts but concentrate instead on the task immediately ahead of us, which is to locate the Vorcan Portal, a hidden gateway leading to the labyrinthine Caves of Vor.

A few of the Skernians we'd met at the cave resolved to join our mission whilst those whose families had fled went off in search of their loved ones. The Skernians who remained claimed to know the region well and were confident about guiding us to the portal but they had neither the knowledge nor the skills to gain access, so I would again have to draw on my own powers. Our reason for taking this route is that the caves provide a short cut to the Northern Territories, avoiding the extremely inhospitable terrain above ground.

Day Forty-three

It is many years since I myself used the cave system, so I cannot predict the dangers which may await us but I do know of nomadic peoples who have reportedly discovered other access points and have spoken of a monster that lurks within. A few hours later, led by the Skernians, we crested a small hill and were confronted by a stone doorway of truly awesome scale. Its surface was covered in small inscriptions, most of which were written in ancient tongues, and the portal's edges were so closely fitted to the towering stone aperture that one could barely see the join.

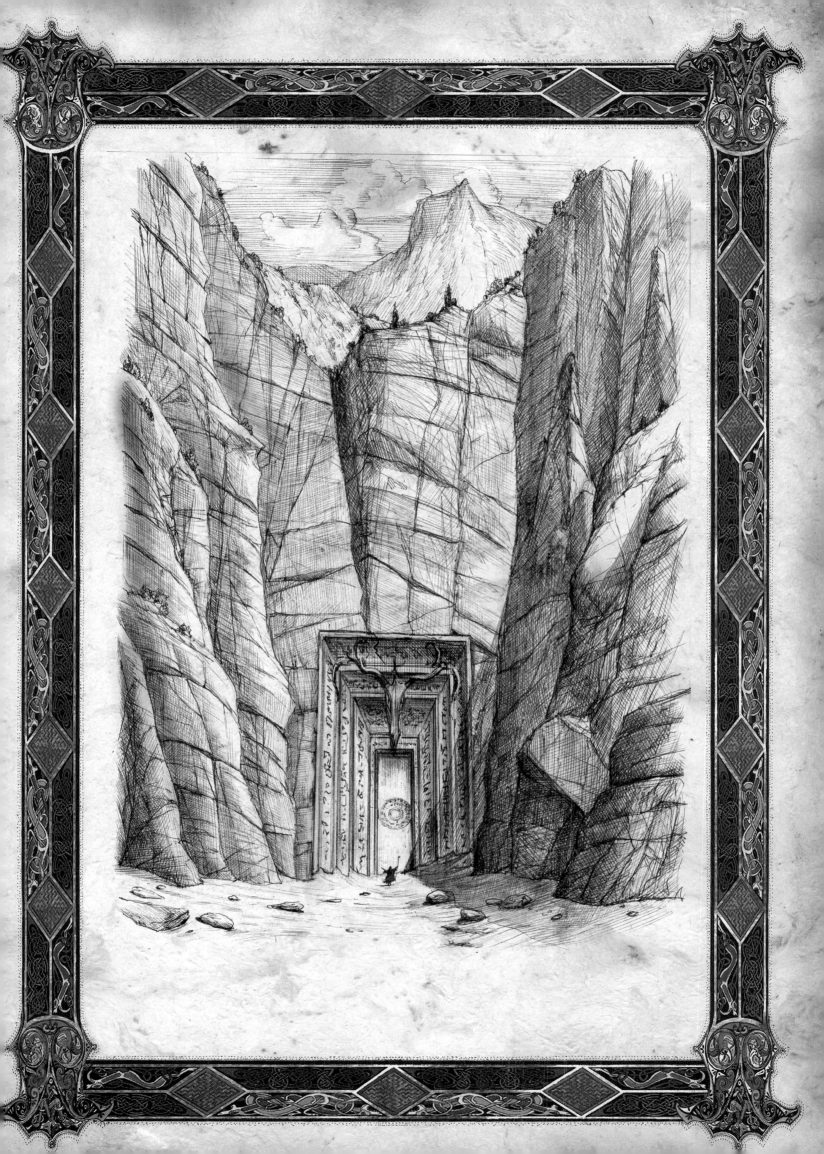

After instructing everyone to take a rest nearby, I removed the Amulet from the back of the book and placed it on the sandy ground in front of the portal. I was alone as I began the ceremony that unlocks the great door but a few moments later, when the Amulet was hovering before me, I was joined by Amaleh who looked on in wonderment. Slowly the mighty stone slab began to move, edging away from us a little at first and then, with the sound of rock grinding against rock, rising upwards to reveal the cavernous space beyond. The noise brought many running across to investigate but I was pleased when Amaleh, instead of rushing inside with the others, merely enquired whether I was feeling all right after my exertions. I told her I was fine and hoped that she didn't detect the hesitancy in my movements as I walked slowly away from her and returned the Amulet to the book.

Our small army was assembled once again and we began our exploration of the first section of the caves. Torches were lit in order to penetrate the intense darkness but further ahead we could see shafts of sunlight beaming down through the roof of the vast cave, lending it a cathedral-like atmosphere. In due course we arrived at a clifftop and paused awhile, taking in a spectacular view of a long subterranean lake that stretched ahead of us as far as we could see. We were awed by the grandeur of the setting but could not escape a gnawing feeling of apprehension.

As we absorbed this spectacle we became aware of a winged creature circling in the far distance and little by little it drew closer, finally revealing itself to be a small dragon ridden by Bensandas, Lord of the Caverns. The natural wariness of the men subsided when they saw me greeting my old friend, whose tame dragon snorted vigorously as it settled on the ridge beside us. I expressed surprise that the creature he rode when patrolling the caves had somehow remained unaffected by Ganzicus's evil but Bensandas apparently knew nothing of the troubles in the kingdoms above. Before saying farewell I showed him a map of our intended course through the cave system and he helpfully suggested an alternative route which avoided sections rendered impassable by recent volcanic activity. With this recommendation came a warning that we would be likely to encounter the Great Beast of Gratnor at some stage but there was no way of knowing whether this monster had also escaped Ganzicus's influence.

A narrow path led down from this point to a track that skirted the edge of the lake and after a few hours we found a sunlit meadow in which to rest. A more incongruous scene it would have been difficult to imagine, as the warriors stripped off and bathed in the shallow waters at the edge of the lake and then frolicked like children, evidently much relieved to be alive. When night came, however, and we pitched camp further along the shoreline, the darkness was again truly intimidating. We lit fires on which to cook but away from their glow the visibility was so poor that most of us had to locate our tents by feel alone.

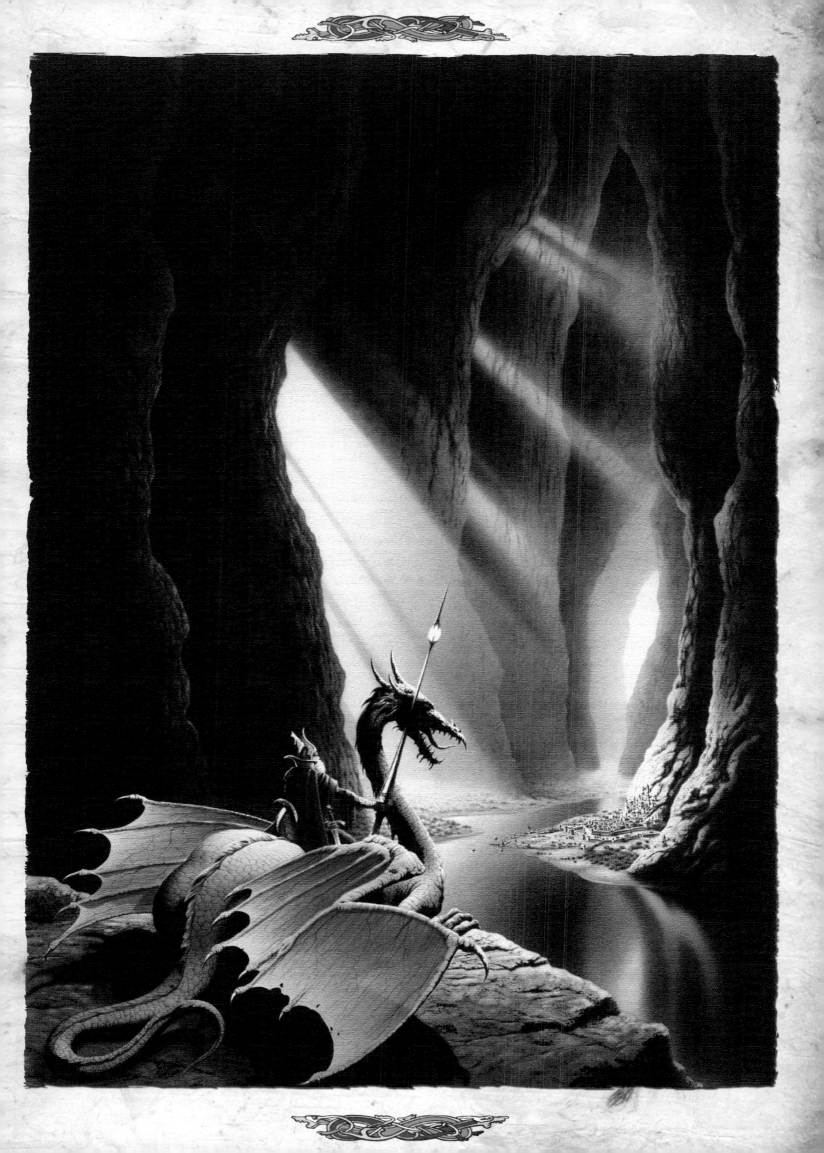

The sounds that echoed through the cave's chambers during the night were many and varied, and I recalled from my last visit just how unnerving they can be. On this occasion, though, the animal cries that came drifting out of the night were accompanied by a low groan which was almost plaintive in its tone. This I could not identify but from its pitch and the way it reverberated through the tunnels, I could be reasonably sure that the beast responsible, though large, was still quite some way distant.

Day Forty-four

Waking in the half-light of this strange netherworld early this morning, I was pleased to see Bandred readying everyone for the next stage of the journey. From here on in the path was to descend yet further into the bowels of the earth, where sunlight never penetrates and the torches would prove invaluable.

This was perhaps the most constricted part of the cave system and as the tunnel walls appeared to close in around us so a rising sense of panic began to manifest itself. Fortunately it was not long before we found ourselves passing into a much larger chamber, although the light from our torches was insufficient to penetrate its furthest recesses, so we could only guess at its true size. Still we could hear the low groan rumbling out of the darkness and reminding us that we should remain on our guard.

At one point there was a flurry of activity at the head of the group, as a warrior stumbled over what he took to be the head of a dead dragon. Upon closer inspection, however, it was apparent that what we had found was the creature's discarded skin, a pale, dry husk which closely resembled that which a snake would shed as it grows. The head itself, which was about the length of a man's body, was remarkable for the amount of detail it revealed. Nostrils, eye sockets and even the dragon's ears were all perfectly preserved in the parchment-like surface under the glow of our torches and as we moved to take samples for the book we were surprised by the fragility of the scales, which flaked away from the surface under our touch. We could not tell how long it had been there or how many times the creature may have shed its skin since, so the specimens we took told us nothing about the size of the dragon we may shortly confront.

Day Forty-six

For about two more days we pressed on through perpetual darkness, able to mark the passing of the hours only by trusting to instinct and the hunger pangs that heralded our usual meal times.

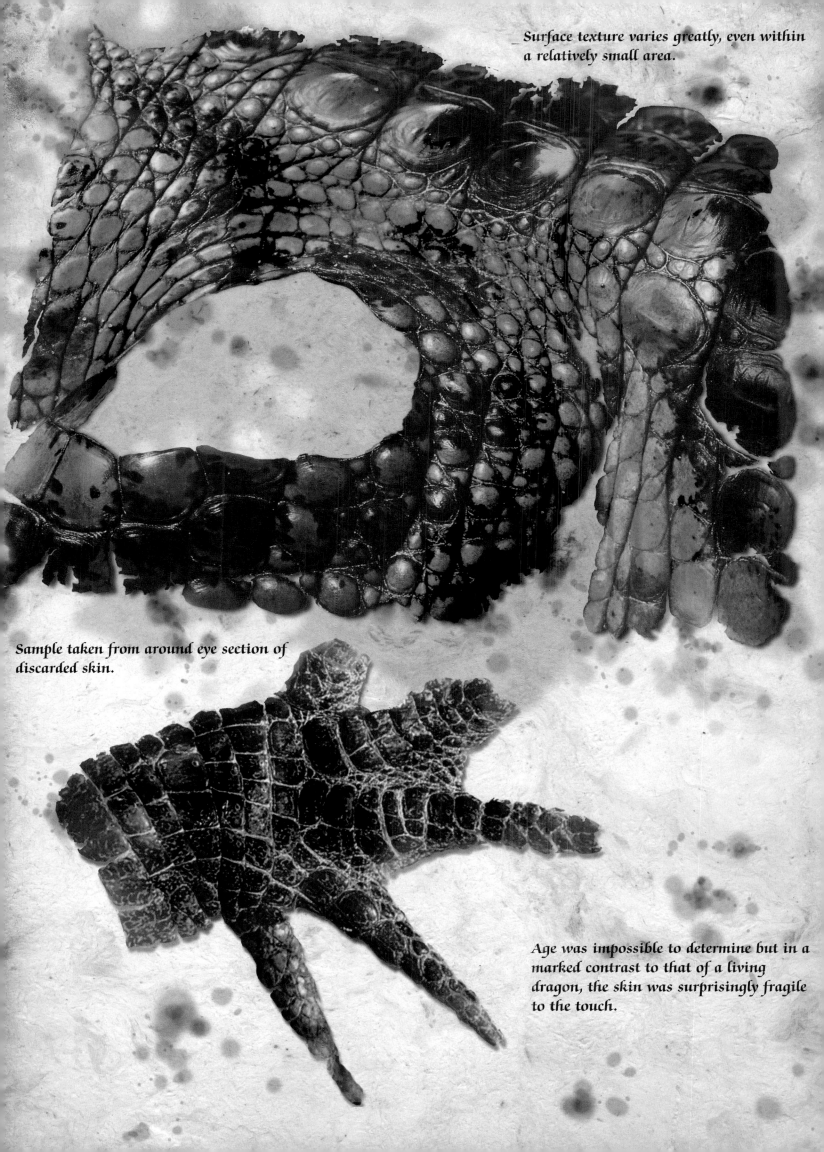

Surface texture varies greatly, even within a relatively small area.

Sample taken from around eye section of discarded skin.

Age was impossible to determine but in a marked contrast to that of a living dragon, the skin was surprisingly fragile to the touch.

A faint orange glow ahead of us eventually brought relief from the monotony and although we had no inkling of its nature we hastened towards it. Distances were hard to gauge in the gloom of the caves but by and by we began to make out a small arch at the head of the chamber and identified this as the source of the light. As we neared the doorway I went on alone, carefully edging towards a point where I could see beyond the arch without having actually to pass through it. An immense hall gradually revealed itself to me, lit by the glow of a lava lake that formed the floor of the cave. A narrow stone staircase appeared to lead down to a narrow bridge which spanned the bubbling liquid and, beyond that, another arch led onwards into the next section of the passages.

Off to one side, something very large stirred in the shadows and accompanying this movement came a scraping sound like the chafing of leather against stone. Cautiously, I crept right up to the arch and positioned myself so that I could get a clearer view of what lay within. I beheld a dragon which was at least as large as any we'd encountered so far but it differed from the others in one crucial way. Its eyes were completely white and from the way it moved it appeared to have lost the use of them altogether. Long, rasping breaths escaped its nostrils as it sniffed the air, perhaps scenting our intrusion into its world, but the smell of the sulphur that rose in acrid clouds from the lake below was almost certain to mask our presence.

I assumed this to be the dragon Bensandas had told us about but it did not exhibit the same unbridled aggression of the others we had seen and, from what I could tell, it had grown far too large to escape its cavernous cell. For a moment I felt a pang of sympathy for the great beast and I resolved that we should leave it undisturbed if we could. I returned to the main group and reported my findings, whereupon it was decided that we should attempt to slip quietly past by using the causeway to reach the far side of the chamber. As a precaution, I conjured up the protective bubble that had protected us from the dragonets, knowing that it could not repel this creature in the event that it decided to attack us but that it would at least serve to muffle the clatter of the horses' hooves and the coughs of those who found the sulphurous fumes too strong to bear.

From this point onwards the tunnel began to rise slightly. At first the incline was almost imperceptible, masked by the unevenness of the ground underfoot, but as our breathing grew more laboured it was impossible to escape the conclusion that we were climbing again. It was during this stage of the journey that my thoughts travelled back to our meeting with Bensandas and his dragon, giving rise to an idea. It was obvious that our fighting strength had diminished greatly since we set sail and I too have felt my powers to be waning. We can only guess at the battles ahead of us but without some form of support or assistance our chances of further victories are extremely slim. Given the right circumstances and assuming I still have sufficient strength, there is just the possibility that I may be able to perform a ceremony that will reverse Ganzicus's malevolent influence on at least one of the corrupted creatures. By this means we could perhaps make it our servant instead, training it to engage the other dragons in aerial combat whilst being ridden by one of our warriors. I pondered this thought as we continued on our way.

Chapter Eight

Nature Defiled

With each step that took us nearer to the surface the mood within the group gradually brightened. The route suggested by my friend had served us well and if I was right the path on which we travelled would shortly deliver us to the exit in the Ghazeen Valley.

The territory we have bypassed by using the caves is known as Terra Balena and is covered with spectacular but largely impenetrable rock formations. As we emerged blinking into the sunlight a few hours later some of these strange sandstone towers could clearly be seen and the artists who accompanied us were so taken with their exotic forms that they could not resist making some sketches while we rested.

Day Forty-seven

Ahead lay the Ghazeen Valley, a vast swathe of pastures and woodland which is noted for its outstanding natural beauty and great variety of flora and fauna. A grassy bank led downwards and at the foot of the slope a small stream glinted in the sun. The scene was idyllic, a picture of Nature at its most perfect, but I quickly realised that all was not as it seemed. As we crossed the stream on a small stone bridge I happened to glance down into the reeds and was perplexed to see a dark mass of eels writhing in the shadows. Each of them had two heads and there was something deeply disturbing about the contortions of their bodies as they slid against each other, occasionally breaking the water's surface with violent thrashing movements. What could have a brought about such a vile abomination as this I had no idea but before we'd travelled much further other such perversions of nature presented themselves.

We were crossing a meadow when one of the artists was stung by a butterfly that had settled on his arm and it was only by the application of a powerful balm that I was able to prevent the resulting lurid purple rash from spreading beyond his shoulder. Shortly afterwards, as we pushed through a slightly overgrown section of the path, a plant appeared to spit a sticky substance into Bandred's eye, causing a painful burning sensation and considerable swelling.

After relieving his discomfort by splashing copious amounts of water into the eye, I went back and examined the plant. The species, a variety of orchid, was familiar to me and I knew it to be totally harmless in normal circumstances. Others complained of barbed leaves which snagged on their clothes or skin and tall grasses that appeared to secrete potent irritants. Something was seriously amiss here and I could think of only one person to whom I could attribute this cruel corruption of Nature's works: Ganzicus himself.

Day Forty-nine

It seemed as if the entire Ghazeen Valley had been invaded by his evil. Like a cancer, it had crept insidiously into almost every living thing and in a strange way this distortion of natural beauty brought about a greater sense of shock than that caused by any of the fire-breathing dragons we'd encountered on our journey. Feeling compelled to exercise extreme caution, we found our progress slowing to a crawl and at one stage a warrior took it upon himself to slay a deer that happened to stray across our path, for fear that it too may represent a threat. Amaleh was very upset by this incident but I think she understood his actions when I explained what Ganzicus had done to this once beautiful place.

Day Fifty-one

After four days of trekking we were about to arrive at the head of the valley this morning and were quietly congratulating ourselves on escaping this threatening environment without serious injury, but it was not to be. Within sight of the relative safety of the Veliden Pass, one of the warriors fell prey to a small monkey, which dropped silently out of a tree and ripped open his throat with its clawed hand before any of us could react. The monkey itself was swiftly put to death by those who followed and upon examining it closely I felt revulsion at the way its hands had mutated into such vicious weapons. The claws were extracted by an assistant for possible inclusion in the book.

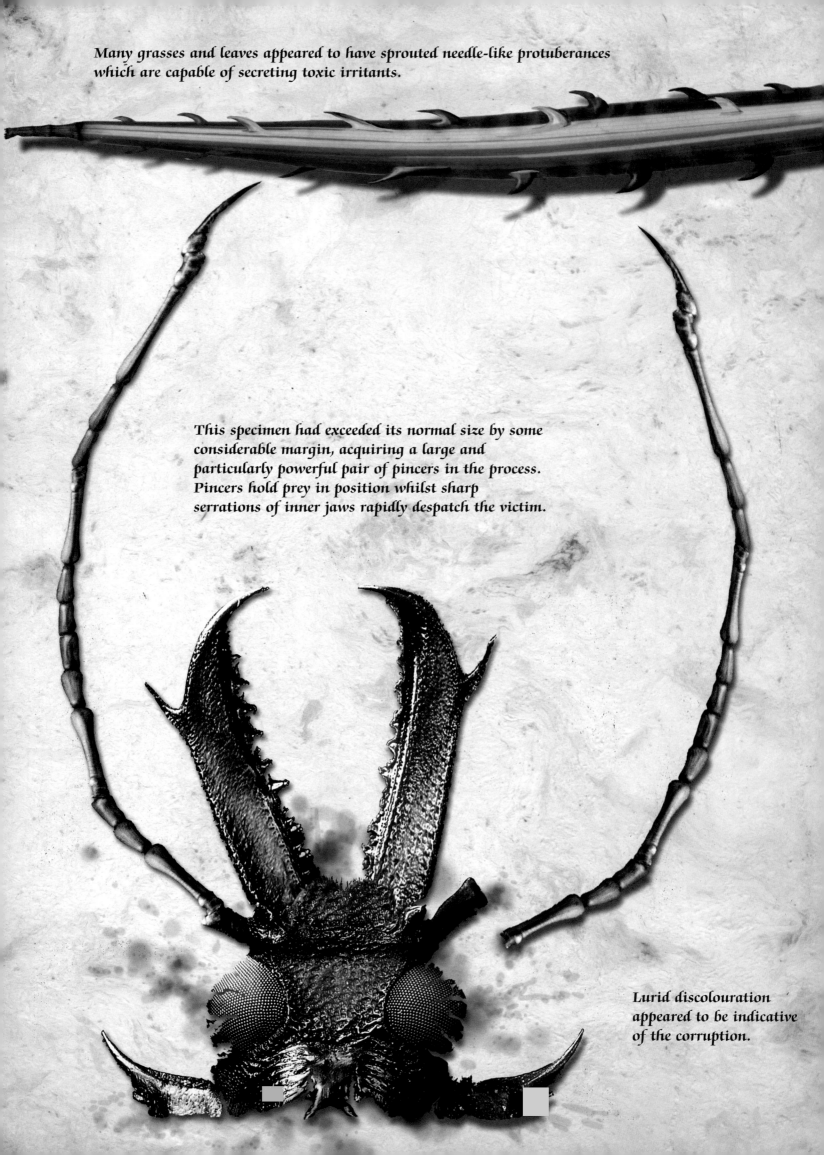

Many grasses and leaves appeared to have sprouted needle-like protuberances which are capable of secreting toxic irritants.

This specimen had exceeded its normal size by some considerable margin, acquiring a large and particularly powerful pair of pincers in the process. Pincers hold prey in position whilst sharp serrations of inner jaws rapidly despatch the victim.

Lurid discolouration appeared to be indicative of the corruption.

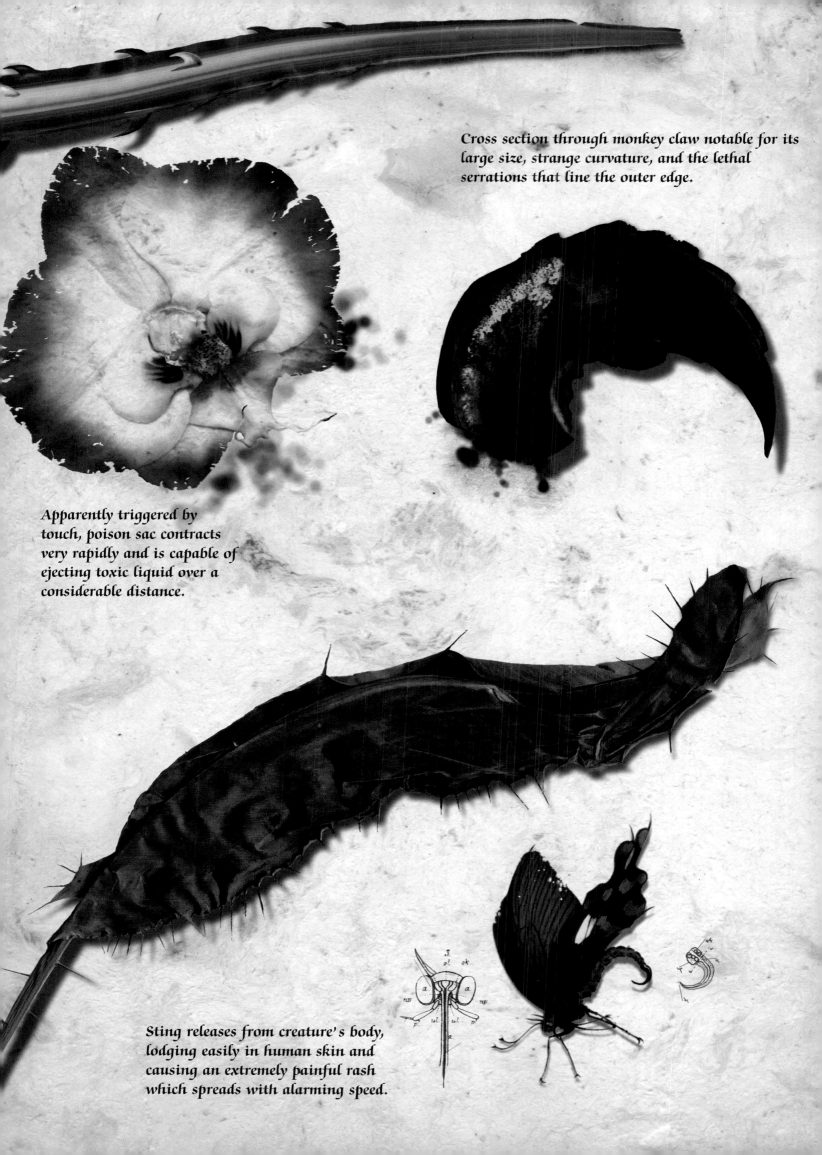

Cross section through monkey claw notable for its large size, strange curvature, and the lethal serrations that line the outer edge.

Apparently triggered by touch, poison sac contracts very rapidly and is capable of ejecting toxic liquid over a considerable distance.

Sting releases from creature's body, lodging easily in human skin and causing an extremely painful rash which spreads with alarming speed.

Day Fifty-four

Our objective is the Northernmost tip of the Four Kingdoms where the infamous Dragon of the North resides, but before we can head up into the mountains we must detour via Sankara Castle. According to reports we received before we set out, a winged beast known locally as Gorlenah had driven out its inhabitants and had been terrorising several villages nearby. The castle nestles in the shadow of high mountains and is ringed by a series of natural lakes, many of which are characterised by the steep-sided cliffs that surround them.

A plan began to form in my mind, and by the time we pitched camp tonight I had decided that this would be the dragon we would attempt to capture and liberate from Ganzicus's influence.

Day Fifty-five

By mid-morning today we had nearly reached the castle but, instead of pressing ahead, we conducted a thorough survey of the whole area. It took several hours but I eventually found a sunken lake that suited my needs perfectly. It was not immediately apparent what purpose had been served by these lakes and the landing stages that bordered them but we were fortunate in finding a large quantity of heavy chains lying around. These we can almost certainly put to good use, for my plan relies not only upon our ability to entice the creature from its lair but also to restrain it on a small rocky island in the centre of the lake.

Day Fifty-six

At first light we began the preparations, which included securing a complex cradle of heavy chains to several key points around the water's edge. I despatched a team of three scouts to the castle but when they had failed to report back after some considerable time I began to fear for their lives.

Afternoon was fading into dusk when the peace of the camp was disturbed by a terrible commotion and I looked up to see two of the three scouts running towards us at great speed. Not far behind them, a monstrous beast, which I took to be Gorlenah, swooped low over the ground, expelling huge licks of flame from its gaping mouth. Around me a desperate scramble for cover ensued, and as the first of the scouts stumbled breathlessly into my arms he hurriedly explained how they'd been watching the castle when the creature suddenly burst through the open drawbridge as if unleashed from the gates of hell. One of their number had been incinerated where he stood but the others had been luckier, hiding out in a crevasse before making a frantic dash for the camp.

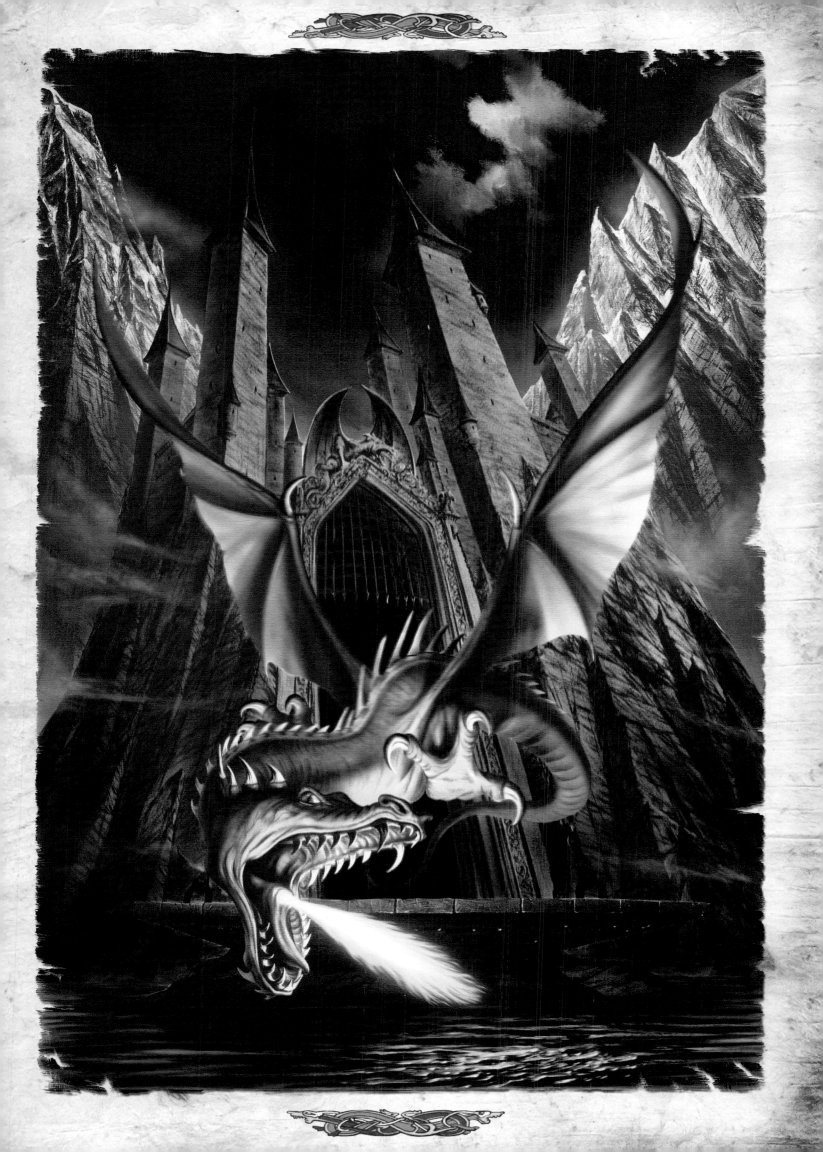

I threw the scout to the ground as the creature passed over us, its head snaking from side to side as its dark, liquid eyes scanned the movements of those below. With a terrifying roar, it banked sharply away and headed out across open countryside.

I had not planned to perform the ceremony of exorcism until tomorrow and would have liked more time to prepare but if the dragon were to approach our trap again tonight we would have to seize this invaluable opportunity.

Within a few minutes it was back, skimming so low over the landscape that it looked more like a fast moving-shadow than a living thing. By now the warriors had assumed their positions and when I gave the signal, ten of them pulled down on huge wooden levers, causing an intricate network of chains to snap taut immediately in front of the dragon's path. The collision was spectacular but much less controlled than I'd imagined it in my head, as the momentum of Gorlenah's body ripped the whole apparatus from its mountings, hurling the bodies of hapless bystanders high into the air. A moment later it had somersaulted into the lake, ending up enmeshed in the chains and sprawled across the island with its tail trailing in the water.

The exorcism would take some time to perform and could be carried out only after the beast had regained consciousness but since this could happen at any time I had to work fast to complete my preparations. Within minutes it was beginning to stir, and it was not long before our captive dragon was fully awake again, straining at the chains, screaming, and beating its wings with unbridled fury. I began the ceremony immediately but considerable time passed before any effect was noticeable, so potent was the creature's rage.

Gradually, as Gorlenah's movements became less frenetic and its piercing screams subsided into a low murmuring growl, it became obvious that the benign influence of the spell was working its magic and driving out the evil. The conclusion of the ceremony brought great relief for me but it was only after I'd performed a series of vital checks that I felt confident enough to sever the chains and release the beast.

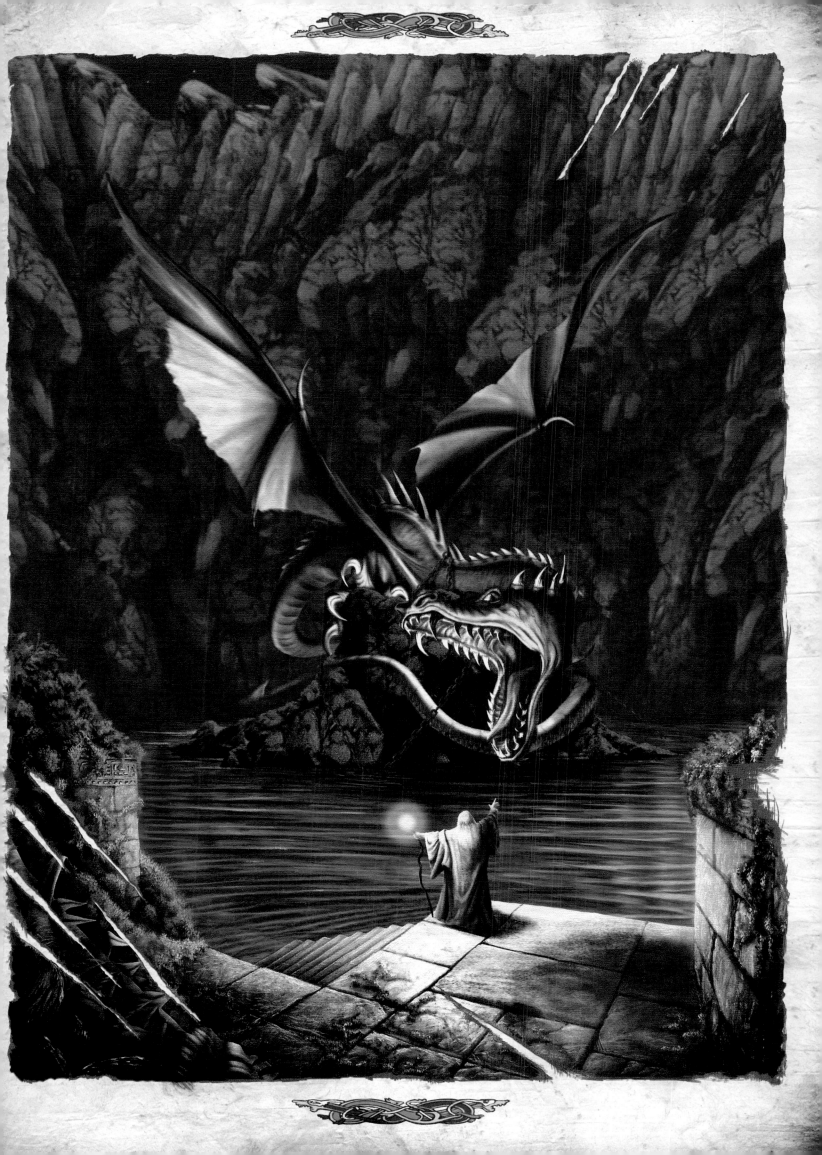

At first she remained on the island, quietly surveying the scene around her as our men slowly emerged from hiding, many of them still unsure whether or not to put their trust in my powers. By now, however, I instinctively knew that the beast would do my bidding, so I hurriedly reassured them and then demonstrated my control over Gorlenah by commanding her to perform a series of aerial manoeuvres, which she carried out with ease. When the creature returned to the island there was a brief round of applause and we found ourselves much heartened by the success of the transformation.

We packed everything up and travelled the short distance to the castle while Gorlenah circled high above us keeping watch. Inside, everything was much as the inhabitants had left it, and although many of the castle's stores had been plundered by rodents there remained sufficient for a good feast. Afterwards I went to my chamber and removed the Amulet from the back of the book. If all went well we would be back at the palace in a matter of weeks and I was keen to see whether the Amulet could provide a window on the developments that had taken place during our absence.

The history of Sankara castle is inextricably linked with that of the Amulet itself and I knew there to be a special chamber somewhere within its granite walls which would assist in the visioning ritual I would need to perform. I eventually found the room I sought in the upper reaches of the North tower and was awed by its scale. On one side it was completely open to the elements and a chill wind was blowing down from mountains of the North Kingdom.

Once again I had cause to curse the stiffness in my fingers as I struggled to position the Amulet in the very centre of the Henscher Ring, an elaborate and highly charged engraving in the chamber's stone floor. The Amulet sprang into life as soon as I began the spell and amazed me with the speed at which it delivered its grim message. A ghostly vision of the King's inner chambers appeared in the air above me and I stared hard into the swirling mist, attempting to establish whether the person I could see lying on the bed was Malacan himself.

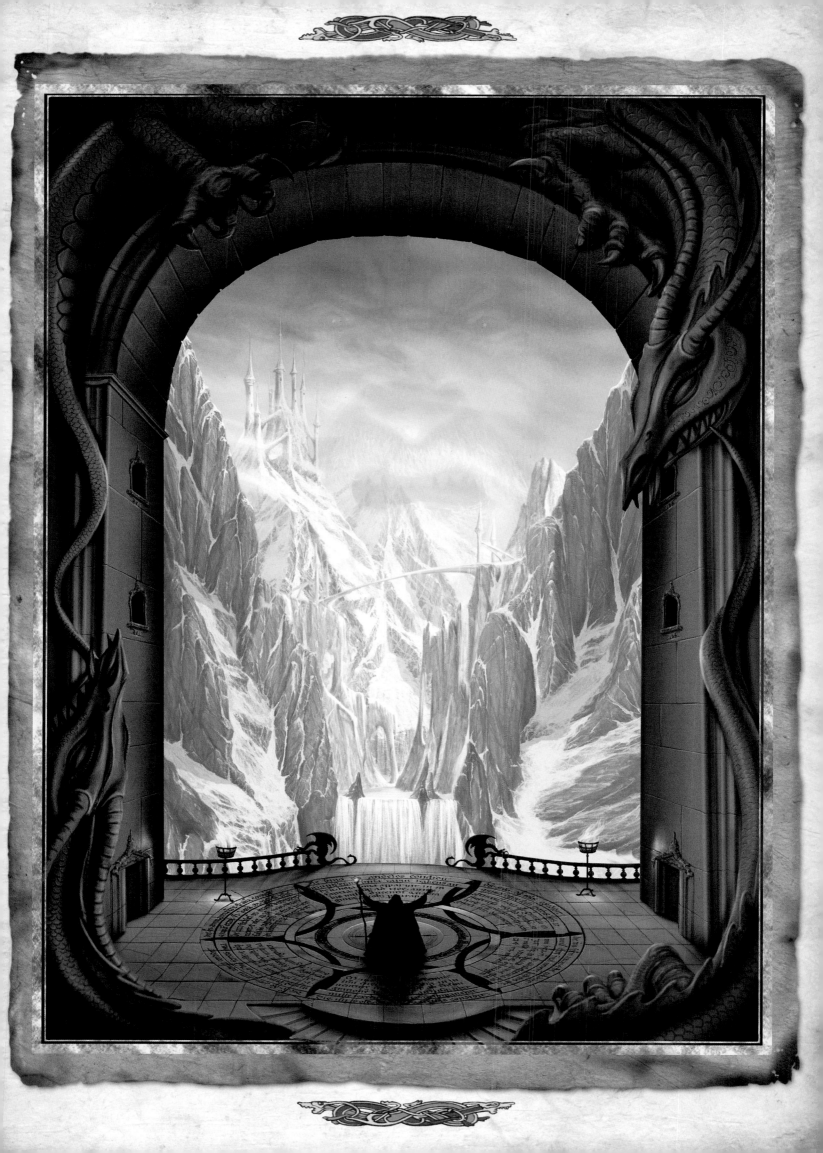

At first I could not be sure, but then a hooded figure I recognised as Ganzicus stepped out of the shadows and approached the bed. He passed his hand slowly over the body before him and then turned to meet my gaze. To my astonishment the voice of my nemesis suddenly filled the room, confirming by its very presence that Ganzicus was aware of my eavesdropping and that he could manipulate the Amulet's powers in any way he wished. The words he spoke next echoed through the icy chamber....

'Your friend is still alive, Septimus – isn't that what you wanted to know?'

I said nothing and a second later he continued.

'He begged me to allow him a peaceful death and he has suffered so, but I could not find it in my heart to release him' he said, his voice feigning mock concern for the great man he'd once served.

'After all, what would be the point of all this madness were the King himself not alive to witness the violation of his empire?'

Ganzicus's rhetorical question hung in the air like a poisonous cloud, reinforcing my belief that his desire for revenge was fuelled by the purest hatred imaginable. Malacan had been denied a natural death and his agonies had been perpetuated merely so that he would survive long enough to observe the usurper's rise to power. The very thought sickened me but as I abruptly terminated the ritual and left the chamber I found that my resolve had strengthened yet further. Now more than ever before, I knew I must not fail my friend.

Chapter Nine

Fire and Ice

Day Fifty-seven

Early this morning I went to check on our dragon and found her sleeping peacefully in a vaulted hall near the castle's main gate. After examining the creature in some detail I realised that her physiology was not well suited to extreme cold, a characteristic she appeared to share with many reptilians. At best the creature would be lethargic in such conditions and at worst her heart rate could slow to such an extent that her life would be in danger, so I reluctantly came to the conclusion that she would not be able to accompany us on our journey to the North Kingdom. The only consolation was that her strength would be preserved and that she would therefore be better able to assist us in our final battle with Ganzicus at the palace.

After discussions with some of the senior Captains it was decided that I should take fifty of the most experienced warriors with me into the high peaks of the North whilst everyone else would travel across country accompanied by Gorlenah in preparation for a rendezvous in the much lower Jorgas Mountains about ten days hence.

A small team was assigned to take care of our dragon during the journey and one of those responsible, Captain Kronson, approached me shortly afterwards suggesting that his considerable equestrian skills would make him the perfect candidate for the potentially dangerous task of gaining mastery of Gorlenah in flight. A special saddle was prepared and, following several near mishaps, Kronson succeeded in making an airborne circuit of the surrounding area mounted on the creature's back.

Day Fifty-eight

Before beginning the trek Northwards the troops that comprised my team appropriated a number of new weapons from the castle's extensive armoury, including a large wagon-mounted crossbow similar to the Madagan we lost at the Kror Passage. I took Amaleh to one side and gave her detailed instructions on how to command the dragon during my absence and she seemed thrilled that I would entrust her with such a responsibility. In truth, however, nobody else within the group would be able to wield the sort of influence over the beast that Amaleh's supernatural gift could give her.

This afternoon I was approached by one of the artists who took from his pocket a piece of rolled parchment, which turned out to be the painting I'd commissioned him to produce a couple of days ago. Although my experience in Sankara's North tower had disturbed me I had felt it worth recording for the book but the strange thing about the work he now held in his hands was the macabre way in which the face of Ganzicus had superimposed itself faintly on the scene.

Bandred elected to join my team, and as we headed off into the mountains we looked back towards Sankara to see the others embarking on their Westward journey. Although the path we took was gruelling in the extreme, for several hours we were rewarded with a stunning view of the ice castle at Andaaja and the spectacular bridge spanning the chasm below.

As we climbed ever higher and the air grew thin we found ourselves having to rest more and more frequently, and it was during one of these breaks that Bandred decided to ask me about his father. I began by telling him of Malacan's childhood exploits and then explained how he'd gone on to become a respected and worthy King by winning the admiration of his people. In the event we talked for most of the afternoon, breathing heavily as we drew deeply on the clear mountain air, but try as I might I could not bring myself to inform Bandred of his father's appalling predicament for I knew it would break his heart. I discreetly wiped away my tears as we continued our arduous ascent.

Day Sixty

This morning our start was badly delayed by a severe blizzard, which blew through the camp during the night, burying much of the equipment in deep snow drifts. We are barely halfway to the highest region but already the temperature has plunged so low as to be almost unbearable. Were it not for the heavy garments and animal skins that were kindly given to us by the people of Tremana we couldn't even have attempted this stage of the journey and I'm reminded, not for the first time, of just how drastically we have all underestimated the rigours of such a protracted voyage.

My knowledge of the Dragon of the North is scant but reports have confirmed that it is undoubtedly under Ganzicus's influence and that its lair is located somewhere on Gorenson Crag. The nest itself is likely to prove inaccessible but the beast will no doubt seek us out long before we reach it, so this is of no consequence. The first evidence that we were headed in the right direction came in the form of a brief sighting of the creature this afternoon, and again it was Bandred's keen young eyes that picked it out, circling high above the peaks and seemingly oblivious to our presence.

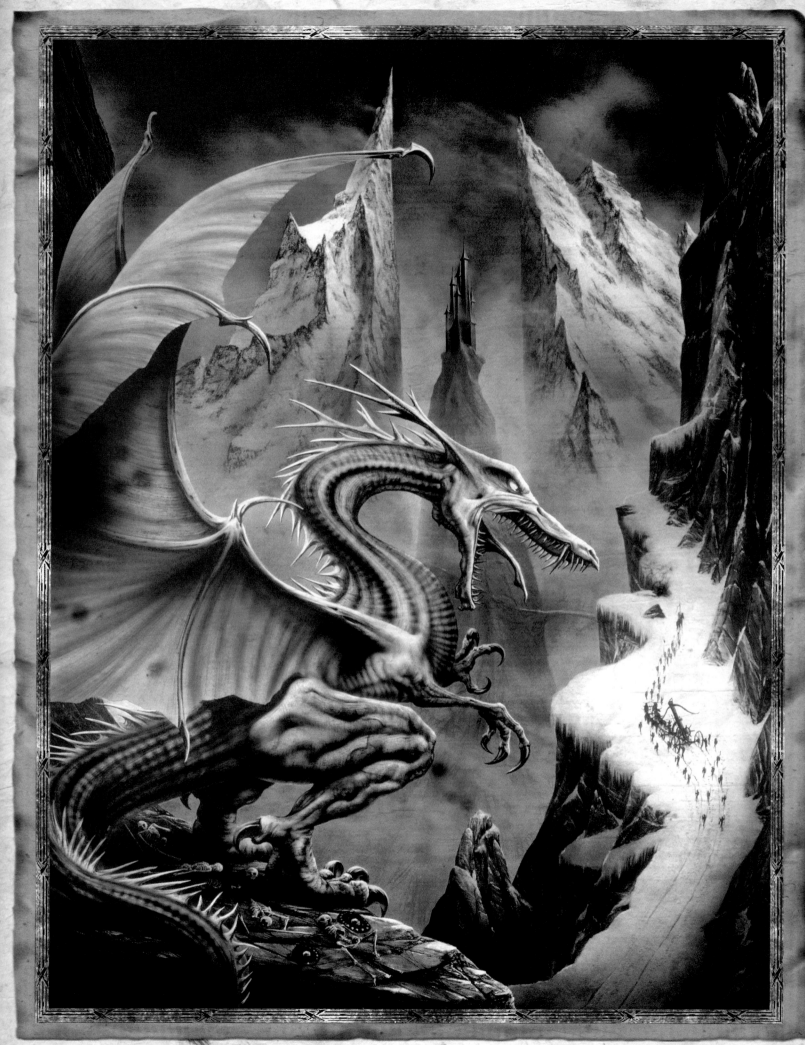

Day Sixty-three

By this evening we had arrived at the upper reaches of the mountains, where a wide track had been cut into a rock face that was almost vertical. Our progress was hampered by the deep snow underfoot and we were further frustrated by the tendency of the path to veer off in unexpected directions, often giving rise to the impression that we were heading directly away from our objective. It was whilst travelling along one of these sections that we had our first encounter with the Dragon of the North, having been alerted to its presence by a roar so loud that it dislodged some of the loose snow from the rocks at the side of the track. The creature was perched on a ledge high above us and we suddenly felt very exposed on the open path. Our apprehension turned to terror when, in the next instant, the dragon leapt from above and dived towards us, bellowing its fury as it approached. With very few places to hide, all we could do was to seek protective cover from the nooks and gullies in the rock face but as a defence this was pitifully inadequate, not least because there were too few of them to accommodate all our troops.

The dragon made two fast passes just above our position before selecting its victim, a warrior called Ferdinand who had chosen to throw himself under the framework of the crossbow. He must have thought that the weight of its great wooden beams would be sufficient to prevent it from being overturned but, sadly, he was to be proved wrong. At first the dragon settled on the track beside the crossbow, touching down with a lightness that belied its enormity. Its lower jaw skimmed the snow as it brought its head right down to the level of the crossbow's front wheels and surveyed the figure cowering underneath with its bright yellow eyes. Ferdinand screamed abuse at the creature in a futile attempt to frighten it off but it would not be dissuaded from pursuing its prey. As its snout gradually edged under the side of the frame he began to kick out violently but by now the oxen attached to the front of the crossbow had begun to panic and were jerking it back and forth, making it even harder for Ferdinand to remain protected. A few seconds later the creature's jaws snapped shut on the warrior's lower leg with a gut-wrenching crunch and it began to drag him out. From where we hid trembling in the shadows, it was difficult to make out exactly what happened next but the creature's grip seemed to fail momentarily, allowing Ferdinand to haul himself back underneath the crossbow. Screaming in agony, he dragged the stump of his badly torn leg behind him, leaving a bloody trail in the snow, and although I was desperate to effect some kind of rescue I could think of no solution that would not entail the certain loss of further lives.

Its patience now exhausted, the dragon let out another terrible roar and then lunged towards the underside of the crossbow, effortlessly flicking the whole apparatus onto its side and simultaneously sheering the coupling that attached it to the oxen. Ferdinand had barely managed to struggle to his knees when the jaws seized him and before anyone could react the creature was airborne again, rising quickly on the powerful updrafts which surround the mountains.

Ferdinand's screams ceased almost immediately, so it seemed reasonable to assume that he'd suffered only briefly but this was precious little comfort after such a shocking episode. The thought that the beast had carried him back to its lair and was tearing his body limb from limb was just too much to bear, especially as many of us had come to regard him as a friend.

I pondered our fate as we pitched camp tonight under the shelter of a broad overhang not unlike the one that had protected us in the Gordacas Canyon and I could not escape the conclusion that we would have to use all our cunning to defeat this beast. If we had learned one thing from our encounters with the various dragons it was that we could not engage these monsters in battle at arm's length. With the crossbow now damaged beyond repair, the tactic of luring the dragon in close was now more appropriate than ever but when it comes to the actual slaying we may have to turn the landscape itself into a weapon, for my own powers are now much diminished.

Day Sixty-four

As dawn broke I clambered up onto the top of the granite overhang which had given us shelter and began an inspection of the surrounding peaks. Sweeping down to the point where I stood was a vast natural bowl which was flanked by two of the highest mountains in the region. If I could trigger an avalanche here the vast quantities of snow and ice contained in the bowl would undoubtedly cast our adversary into oblivion but only if we could successfully entice it into the target area. Returning to the camp, I consulted the others about how this might be achieved and it was agreed by everyone that the more conspicuous we can make ourselves the greater our chances of attracting the dragon's attention. I myself would take up a position on a small spur of rock which protruded from a steep bank just to one side of the bowl, from where I hoped to use what remained of my powers to destabilise the huge mass of snow above.

Over the next few hours we fashioned some large flags from sackcloth and improvised crude drums by lashing several metal shields to the frame of the broken crossbow. Our strategy was fraught with risk and depended not only on split-second timing but also on the courage of the warriors, who would need to remain in the open long enough to persuade the creature to land on the path whist leaving just enough time to retreat to the safety of the overhang when the avalanche began. I doubt that many of us will be getting much sleep tonight. The hour is late and heavy snow is falling as I write.

Day Sixty-five

We put our plan into action soon after waking this morning, and it wasn't long before the commotion caused by the waving of the flags and the clatter of the drums brought the beast soaring up the valley once again. It was a clear day but the resulting glare thrown off by the snow's surface made it difficult for me to judge the dragon's precise speed and position. I squinted into the sun and realised, to my dismay, that the creature was following an altogether different trajectory to the one we'd predicted, thereby highlighting a fundamental flaw in our plan. The vantage point I had selected was in a relatively exposed position some way above the rest of the group and it appeared that the dragon had identified me as a more obvious target than the army below. The dragon's shadow raced across the snow as it banked around the bowl and bore down on the rock where I stood, screaming so loudly that I feared its own cries would trigger the avalanche I'd planned to induce. I had no choice but to throw myself into the deep, powdery snow that surrounded the rock and hope that my body would be hidden from view as the creature flew by. Twice it passed low overhead, appearing not to notice me as it did so, and when I heard shouts rising from below I guessed that it had at last turned its attention to the others.

When I lifted my head I could see that the dragon had landed on the lower ledge and was already snapping tentatively at the warriors who baited it with spears and rocks. This was undoubtedly the moment for me to play my part but I needed to ascend the rocky pinnacle again before casting the spell. After a frantic scramble I regained my original position and was not long into the ritual when the first low rumblings began.

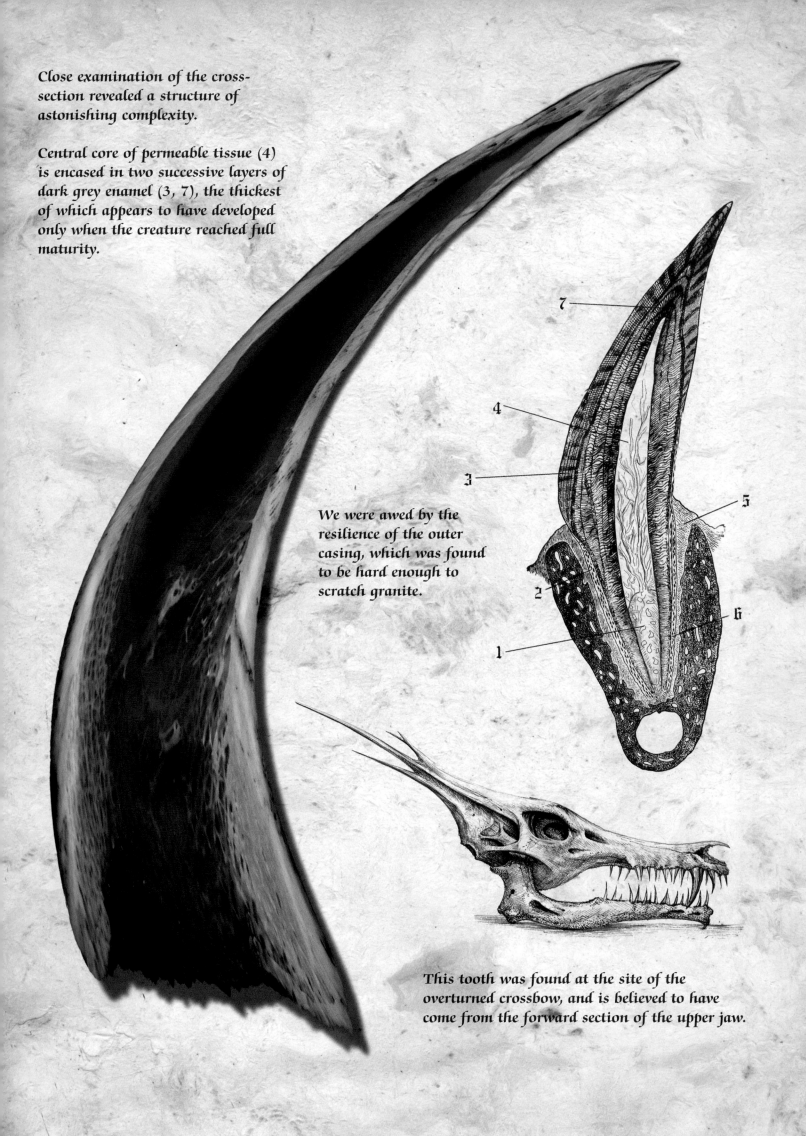

Close examination of the cross-section revealed a structure of astonishing complexity.

Central core of permeable tissue (4) is encased in two successive layers of dark grey enamel (3, 7), the thickest of which appears to have developed only when the creature reached full maturity.

We were awed by the resilience of the outer casing, which was found to be hard enough to scratch granite.

This tooth was found at the site of the overturned crossbow, and is believed to have come from the forward section of the upper jaw.

Below me the dragon was too preoccupied to notice the huge sea of whiteness slipping away from the mountainside. As the sound grew into a deafening roar the men started to turn away from the creature and begin their desperate dash for cover. The dragon took a giant leap forward as if it were about to follow them into the cave but instead of pursuing its quarry it turned its head skywards, suddenly alerted to the crescendo above.

At first it struggled to identify the source of the noise. The avalanche was still just beyond the dragon's line of sight and its roar boomed around the mountain in a confusing series of echoes which appeared to come from nowhere and everywhere.

Leaping suddenly into the air, it was caught by the full force of the avalanche as it thundered over the top of the overhang and was propelled violently downwards into the chasm, rapidly disappearing in reams of white cloud.

Day Sixty-seven

We could not have hoped for a more successful outcome than that which has come to pass. Thankfully the weather remained clear for the rest of today and we were able to make good progress on our journey South. As we travelled I reflected on the vision of Ganzicus that had been revealed to me by the Amulet and the fleeting exchange that had told me much about his motives but nothing about his fighting strength. Had he some kind of army at his disposal, I wondered? Were there yet more dragons that we didn't even know about? Answers there were none, but Ganzicus's powers were now so great that we might expect our enemy to take any form whatsoever and the only certainty was that one or the other of us would ultimately triumph.

Intent on covering as much ground as possible before nightfall, we pressed on through the half light of dusk and as we walked I became aware that Bandred was at my side. For a while he made small talk about the dramatic death of the Dragon of the North but before long the conversation took a turn which caught me off my guard.

'Amaleh told me that Ganzicus is holding my father captive'was all he said, but in speaking these few words he revealed not only his awareness of the situation at the palace but also the fact that Amaleh had been privy to my vision.

I could not find it in myself to blame her for failing to keep our secret and as Bandred spoke of his desire for vengeance I realised that I may well have been wrong to keep the truth from him. If he was envious of Amaleh's gift he did not show it, and as we talked about the confrontation to come he sounded more and more like his father, the man I had come to respect so much.

Day Sixty-eight

Since setting off this morning our route has led us towards the West and our intended rendezvous with the others at the Jorgas Mountains. Still the weather remained good and our spirits were already high when we sighted Gorlenah swooping down the valley towards us with Captain Kronson looking confident in the saddle. Less than an hour later we were reunited with our friends and the men who'd accompanied me began recounting the adventures they'd had in the Northern Territory. The mood was victorious but the rounds of congratulation were rudely interrupted by a feral scream which rang out in the distance, rekindling the fear in everyone's hearts.

I knew of no dragon that inhabited this region and it gradually dawned on me that Ganzicus may have acquired the power actually to create these beasts, a theory that was supported by my original vision in which he'd appeared to launch a vicious-looking hatchling from his arm. It seemed inevitable that we were about to come under attack yet again. I therefore asked Captain Kronson to get into the saddle as I plucked an arrow from the armoury. Hastily, I cast a simple spell across the its metal tip and then handed it to Kronson, explaining that the charmed arrow could temporarily subdue a dragon but only if the tip found its way into soft tissue.

The creature announced its arrival with another guttural scream of startling ferocity. Still we could see nothing but the unearthly and deeply disturbing cries echoed through the mountains around us, disorienting many of the warriors and panicking the livestock.

It was impossible to predict the direction of attack and although our vantage point afforded clear views on most sides there were many blind spots in the canyons between the peaks. Captain Kronson sank low into the saddle and tightened his grip on the reins, not least because Gorlenah was becoming extremely agitated by now and was clearly readying herself to take flight. As we waited nervously for our foe to reveal itself our dragon's keen reptilian eyes scanned the horizon and with flared nostrils she sniffed the air, sensing the close proximity of a formidable predator and emitting a low growl which gradually became more insistent as the seconds passed.

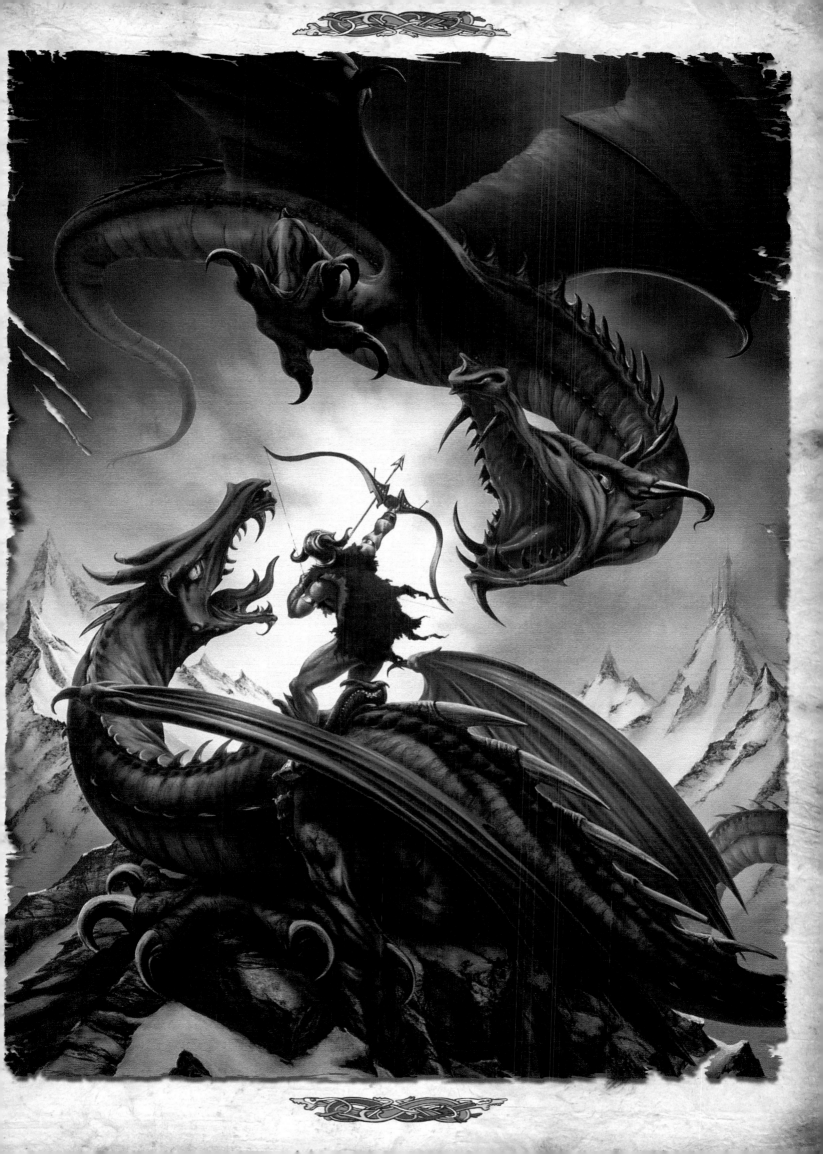

When the growl erupted into a vicious snarl and Gorlenah began to claw frantically at the ground, I realised that we could wait no longer and I signalled the Captain to take to the air, hoping that he had achieved a sufficient degree of mastery over the beast in recent days to overcome the highly aggressive mood that had suddenly overtaken her. The threat of imminent attack would undoubtedly make Gorlenah even harder to control in flight than usual.

My decision had come a moment too late, however, since their opponent, another dragon of roughly equal size, was upon them before they could get airborne, swooping down out of the sun's glare in a high-speed dive. With almost contemptuous ease, it lowered one of its great talons a little as it flashed past, ripping open the thin membrane of Gorlenah's wing. I implored Captain Kronson to remain calm but my cries were all but lost on the breeze, so I was much relieved to see him still in the saddle and raising his longbow as the creature retracted its claws and banked sharply away from the ridge.

A moment later the arrow left the bow, and although its speed defied the eye it was clearly visible as the attacker veered off, embedded in the skin where the dragon's hind leg met its body.

Gorlenah suddenly took to the air, leaping from the ridge at an angle which almost ejected Captain Kronson from the saddle. The injury Gorlenah had sustained did not appear to have affected her manoeuvrability as she sped off in pursuit of the other creature. The pain she was undoubtedly suffering seemed merely to have acted as a spur to greater heights of aggression. For the next few minutes we caught only intermittent glimpses of the dragons as they weaved through the valleys between the mountains. I suspected that the action of the enchanted arrowhead would eventually give Kronson the advantage but it was not until the creatures clashed in the sky above us that I realised what a powerful adversary we were up against.

We looked on in wonder as the two monsters engaged in brutal aerial combat and all the while Kronson fought frantically to stay in the saddle. At first it seemed as if the arrow had failed to have any effect whatsoever but little by little Gorlenah found herself able to break through her opponent's defences, using her claws to land heavy blows which opened up bloody gashes in the skin's surface.

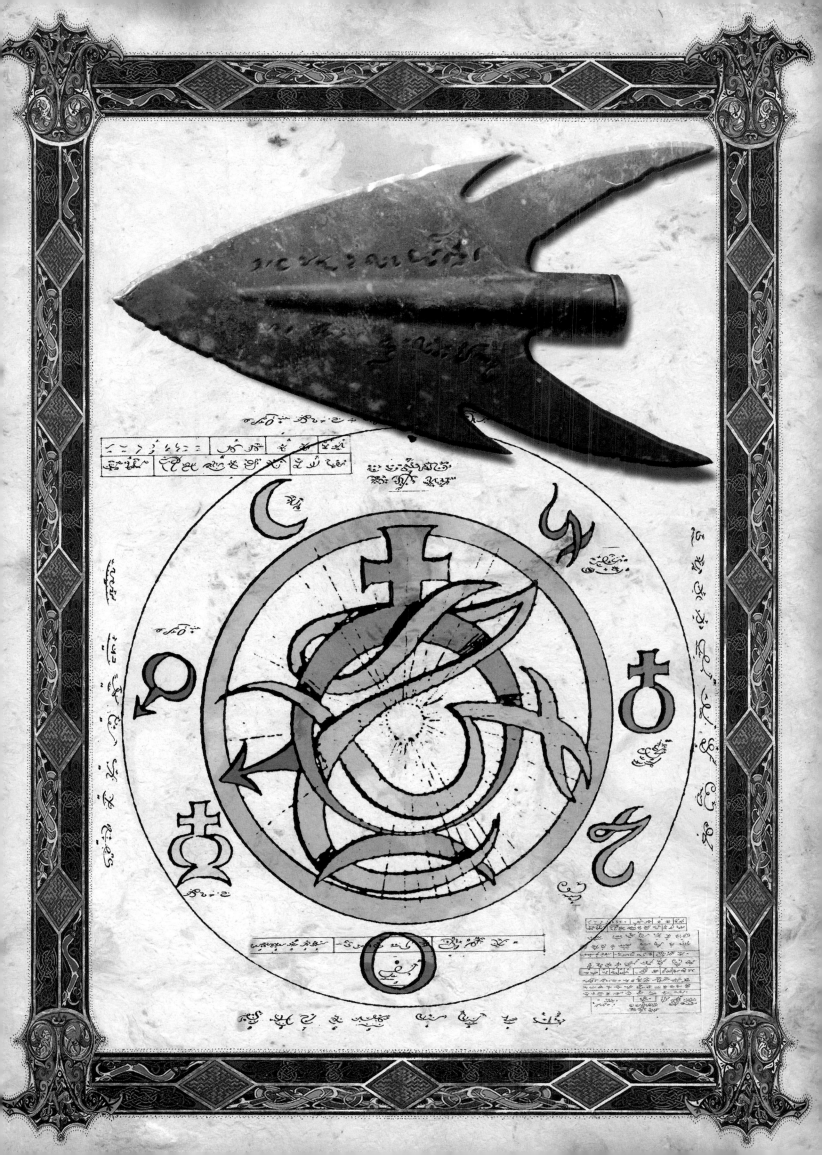

After one particularly vicious exchange Captain Kronson led Gorlenah into a steep dive which opened up a considerable distance between the two dragons. The aggressor gave chase but appeared to be tiring at last and hadn't the speed to catch our dragon. Peeling away sharply, it settled on a nearby ridge to gather its strength but as it took off again a few seconds later Gorlenah came hurtling out of nowhere and seized the creature by the throat with its enormous jaws.

The impact drove them both into freefall but even at this distance we could see that Gorlenah had dealt the monster a fatal blow. With incredible skill Kronson somehow managed to bring his charge under control and avoid a collision with the rocks below but Ganzicus's dragon had not the strength to right itself. A moment later it crashed heavily into the far side of the valley, staining the rock face with its blood.

A tremendous cheer went up and Captain Kronson was feted as a hero when he eventually brought our exhausted dragon in to land and sprang deftly from the saddle. Later, I allowed Gorlenah to gorge herself on her opponent's remains, for she had undoubtedly earned her reward and the feast would give her strength for the battle to come.

Day Seventy

The final stage of our journey has taken us South towards our inevitable confrontation with Ganzicus and the mood has been bright despite the fact that everyone is now fully aware of the situation at the palace.

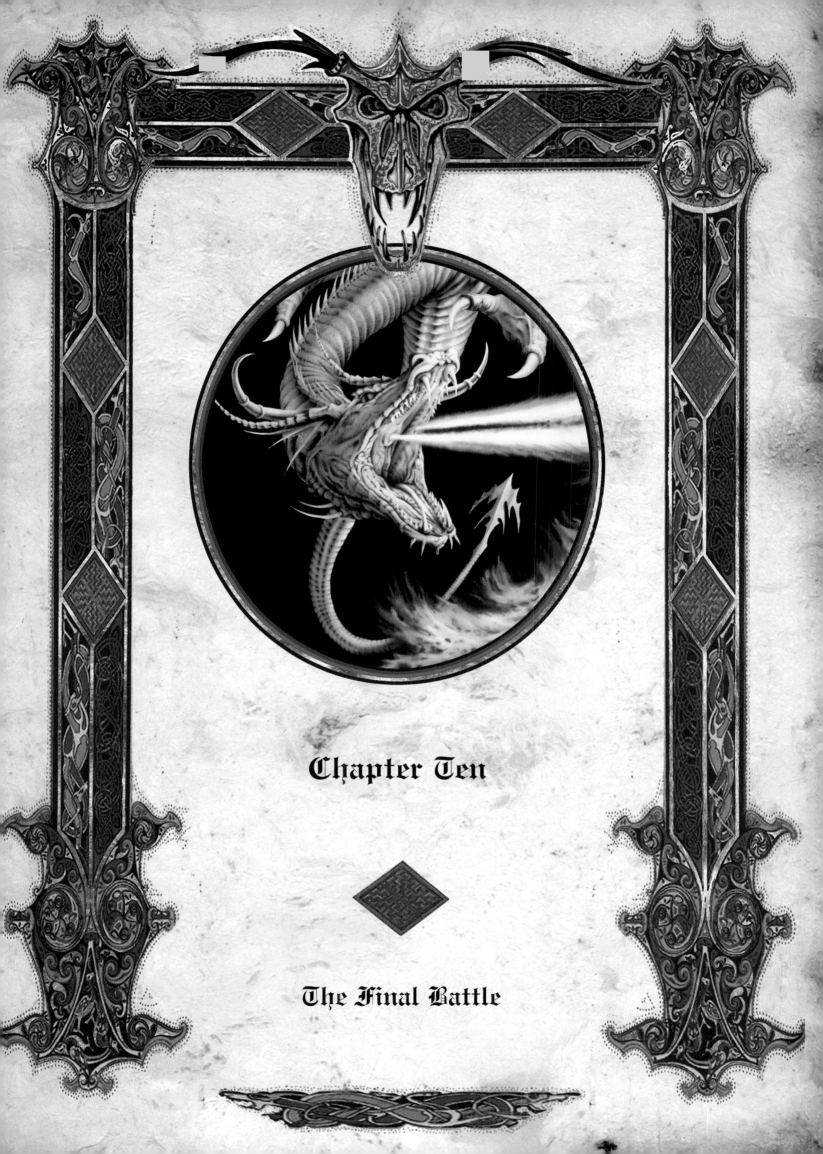

Chapter Ten

◆

The Final Battle

As we made our way down through the foothills of the Jorgas Mountains this afternoon we were suddenly accosted by a group of individuals who had fled the town in fear. They told us much about Ganzicus's reign of terror and the dreaded malaise that had overtaken the region, creeping into almost every living thing and even distorting the very structure of the palace itself with its all pervading evil. By and by, they led us to a vast encampment where much of the population had settled in exile and although it pained me to witness such suffering I took comfort from the fact that there would be many within their ranks who would be prepared to join us in the final battle, including a large contingent of warriors who had not been assigned to our mission.

We spent last night in the impromptu settlement that had been created just outside Villiandra and many of those who'd travelled with us were overjoyed to find friends and family amongst the large numbers of refugees.

Day Seventy-one

This morning I addressed the masses, first giving them a brief summary of our incredible voyage and then asking for volunteers. A great many were prepared to help us storm the palace and I was most impressed by their determination to remove Ganzicus from power despite the danger to themselves.

And so it was that our army began the final march towards home, its ranks now swollen in number by the eager new recruits. As the profile of the palace gradually loomed larger in our sights the afternoon sky began to darken, and I recognised the unusual movements of the clouds as Ganzicus's doing, so similar was their behaviour to those we'd witnessed during our very first encounter. Thunderclaps boomed around us on all sides and these were shortly joined by lightning bolts which came flashing out of the tumultuous sky and arced all the way to earth, shaking the ground beneath our feet.

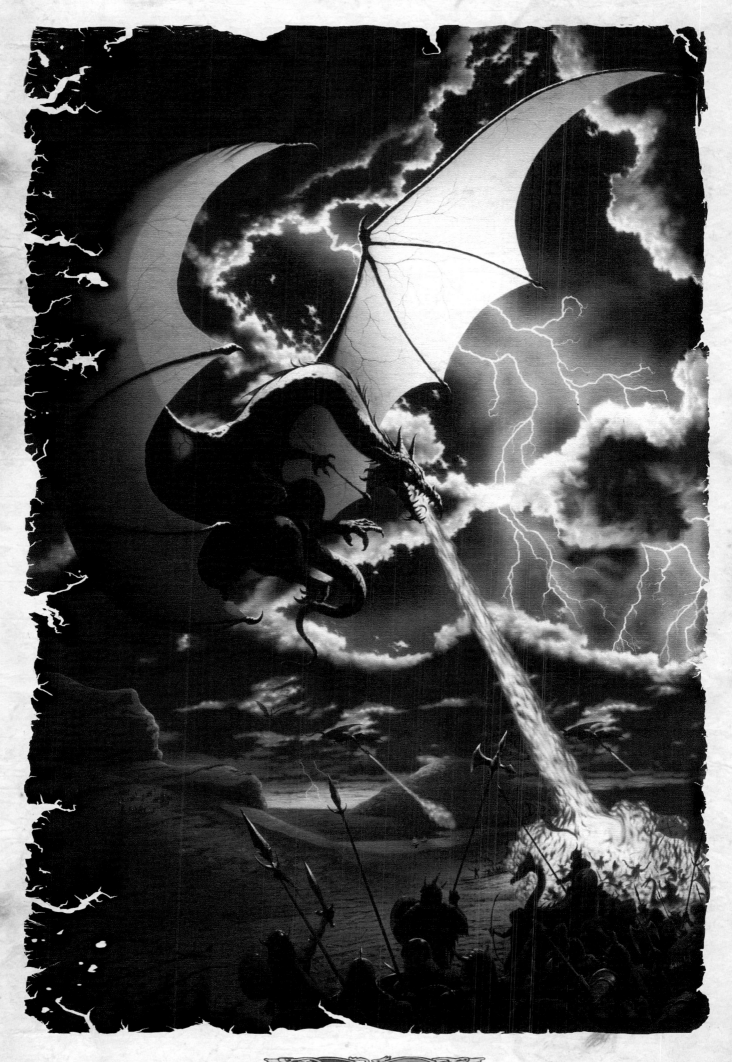

Not one of our men turned back, however, even when the unmistakable form of a giant dragon appeared above the palace. I gathered Bandred and Amaleh tightly to my side and we charged onwards, mounted upon a heavily protected horse-drawn wagon which had been given to us by the refugees.

Ridden by Captain Kronson, our dragon flew a short way ahead of us, and from her warlike cries we deduced that she was more than ready to enter the fray. Meanwhile, Ganzicus's dragon bore down on our army, scorching the ground with sudden bursts of flame and emitting savage screams that were every bit as intimidating as those of Gorlenah. Casualties quickly accumulated around us despite Kronson's best efforts to prevent the beast from attacking our troops and as we looked ahead to the palace itself we were horrified to see yet more of these monsters emerging from within.

There was little I could do to assist our foot-soldiers and before long the whole landscape had become one enormous battlefield. It resembled a vision of hell, in which the bravest of men were forced to grapple with fire-breathing giants many times their own size. I myself had no choice but to focus on reaching the palace for it was only by defeating Ganzicus that I could stem the creation of these demons.

Our numbers suddenly seemed pitifully inadequate in the face of such overwhelming odds but thankfully Gorlenah did not appear to be tiring from her exertions. As she passed low overhead I could see that she had sustained numerous superficial injuries but her will to fight was as strong as ever. We watched her intercept a particularly vicious creature not far from us and her technique was awe-inspiring to behold. As the evil demon closed in on a small group of our recent recruits Gorlenah came charging across its path with talons raised. A second later the claws slammed into the side of the creature's body and the momentum carried them both crashing heavily to the ground, nearly unseating Captain Kronson in the process.

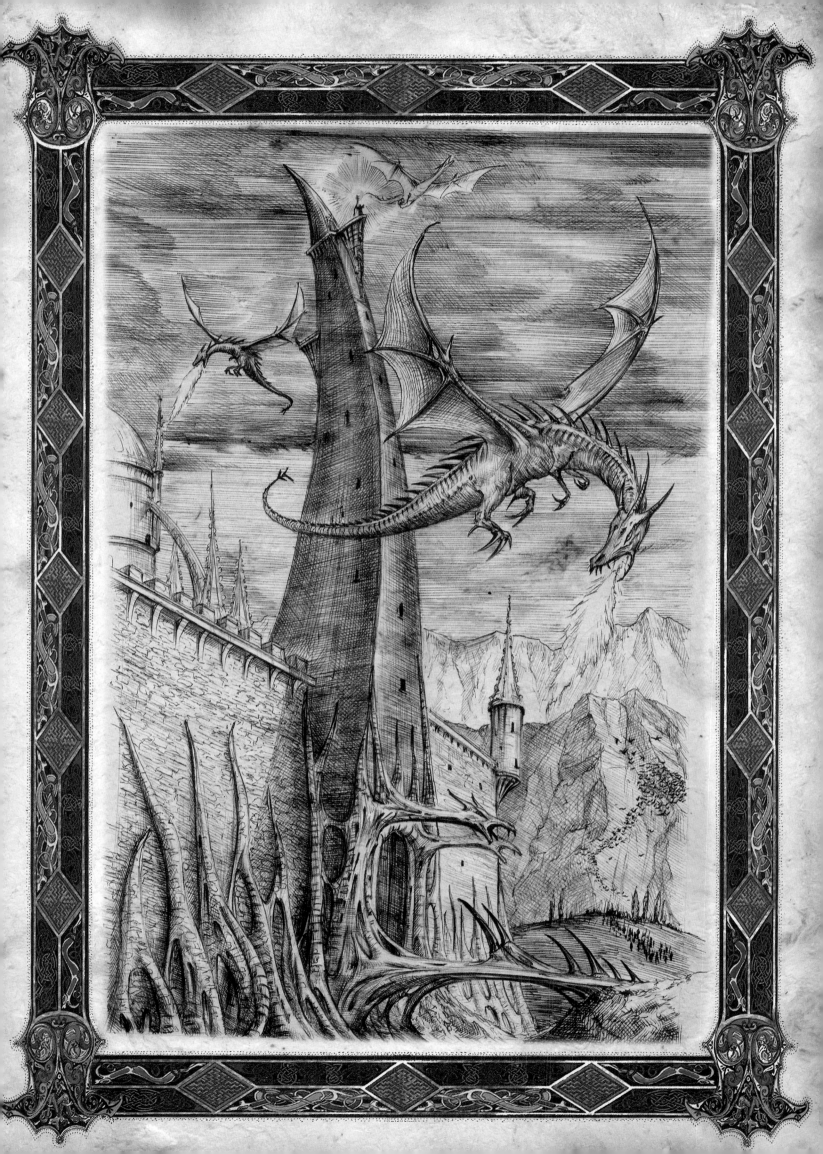

The assault seemed almost clumsy at first but the dust soon cleared to reveal Gorlenah's jaws clamping down hard on the demon's throat and we could only marvel at the efficiency with which she had despatched her opponent. Gorlenah successfully repeated this manoeuvre on several other dragons but elsewhere the fighting was much more chaotic. One group of warriors had managed to disable a dragon by spearing its wing with a lance but the enraged creature fought back with unrelenting fury, eventually seizing one of the men in its mouth and tossing his body high into the air.

As we neared the palace my attention was drawn to a large black cloud spiralling up into the sky above our heads. It was a swarm of dragonets far larger than that which had attacked us in the Gordacas Canyon and the havoc they could wreak in such numbers was too horrific to contemplate.

I'd hoped to use a little-known doorway on the Western wall to gain entry because I knew the main door to be completely impregnable. As we rounded one of the corner towers, however, I realised that Ganzicus must have anticipated my plan because he'd assigned a small but highly aggressive dragon to keep watch over the secret portal. I hastily summoned Gorlenah, who arrived just in time to save us from the beast which perched menacingly on the ramparts above.

While the two dragons did battle, Bandred, Amaleh, and I leapt from the wagon and clambered down into the dry moat that surrounds the palace, falling many times as we did so. The door was directly ahead of us but I wasn't surprised when the others declared themselves unable to see it because Ganzicus's abominable influence had distorted the masonry to such a degree that our access point was all but invisible. Confounding our expectations, it opened quite easily and a moment later we were running through a dark passage on the other side. We hurried to the King's bedside but nothing had prepared us for the shock of seeing Malacan in such a pitiful state. Agony was etched across his face as he stared fixedly back at us, registering barely a glimmer of recognition. I grasped his hand, which was cold and clammy to the touch, and although he was almost too weak to move, my friend slowly raised his other arm from the bed and directed a trembling, bony finger towards the ceiling.

Above the King's chamber was a strange tower that we'd seen on our approach. It appeared to have grown out of the palace itself and closely resembled in style those we'd seen on Arken Island. Amaleh and I fled the room, leaving Bandred to embrace his father.

Still the fighting raged outside, and as we ascended a winding stone staircase within the tower we prayed that the thunderclaps and the battle's clamour would drown out the sound of our approach. Nearing the top, we could hear an unearthly cacophony of fizzes, crackles, and wild screams. Also issuing from the chamber beyond was a shimmering light which played across the stone floor in a variety of shifting hues. We paused for a moment to catch our breath, before edging our way along the wall towards the entrance.

When we reached the corner I motioned to Amaleh to advance no further for the scene I beheld when I glanced into the chamber took my breath away. One side of the room was open to the sky but my eye was drawn to the covered section of the terrace where a series of brilliant flashes danced between the floor and the ceiling, lighting up the stone columns.

The air appeared to be full of malevolent spirits which swooped around the room like demented birds, trailing streams of acrid vapour behind them and in the middle of all this chaos, facing directly away from me, stood a shrouded figure which I knew to be Ganzicus. On the floor in front of him was a large open casket from which a series of unspeakable demons, dragons, and dragonets rushed forth. Although somewhat nebulous as they emerged, the creatures appeared to solidify as they took flight and set off to attack the advancing army below. Lifting the leather sling from my shoulder, I removed the book that had been my constant companion and carefully released the Amulet from the back cover before beginning an incantation I had been rehearsing in my head these past few weeks. I had scarcely reached the third line when Ganzicus interrupted me with a dry, rasping voice which echoed around the chamber.
' Welcome to hell, Septimus'

The shrouded figure slowly turned to look at me and words cannot describe the revulsion I felt upon seeing his face, which had assumed the grotesque countenance of The Dark Dragon of Demonica.

Despite my shock I attempted to continue with the ceremony but was unable fully to charge the Amulet before Ganzicus directed a bolt of plasma into the central stone. I recoiled from the resulting jolt in the energy field, stumbling backwards and falling as the precious Amulet spun uselessly out of my control. I cannot tell how much time passed before I awoke, dazed and half blinded, to see my adversary standing over me and expressing disappointment that I had not proved to be a worthier opponent.

As my vision cleared a little I could just make out the small figure of Amaleh off to one side, silhouetted against the sky, as the Amulet, which had never looked so beautiful, hovered before her. To my amazement, Amaleh then spoke the last few crucial lines of the spell and the central stone glowed fiercely before ejecting a beam of pure white light which raced across the room, piercing Ganzicus in the heart. For a few seconds his whole body was suffused with a light of such intensity that we had to avert our eyes but as the glow dimmed a little and we could look upon him again we beheld the awesome sight of Demonica itself, surging out of his gaping mouth and disappearing into the ether. When his screams abated and he dropped lifelessly to the floor we knew that we had at last put an end to the evil. The macabre apparitions that had filled the room gathered themselves up and followed Demonica into oblivion, after which a glorious sense of peace settled upon us. In death, Ganzicus's appearance had returned to normal and despite all the appalling suffering he'd caused I was gratified that the demon that had possessed him had finally left his soul.

Taking Amaleh by the hand, I gave her my heartfelt thanks for what she had done and led her slowly back down the staircase to the King's chamber. There we found Bandred sitting on the bed and tenderly holding his father's hand. Gone was the old man's tortured expression and in its place was a look of total serenity. The tears we saw in Bandred's eyes confirmed that the King had at last gone peacefully to the other side.

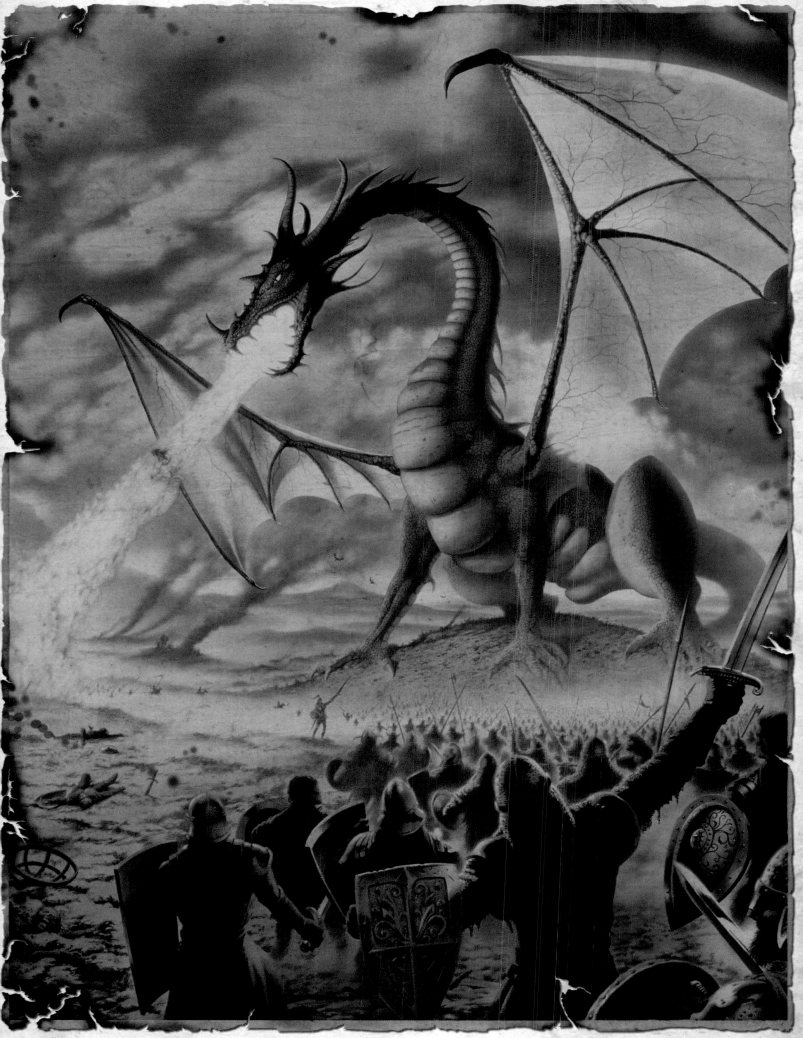

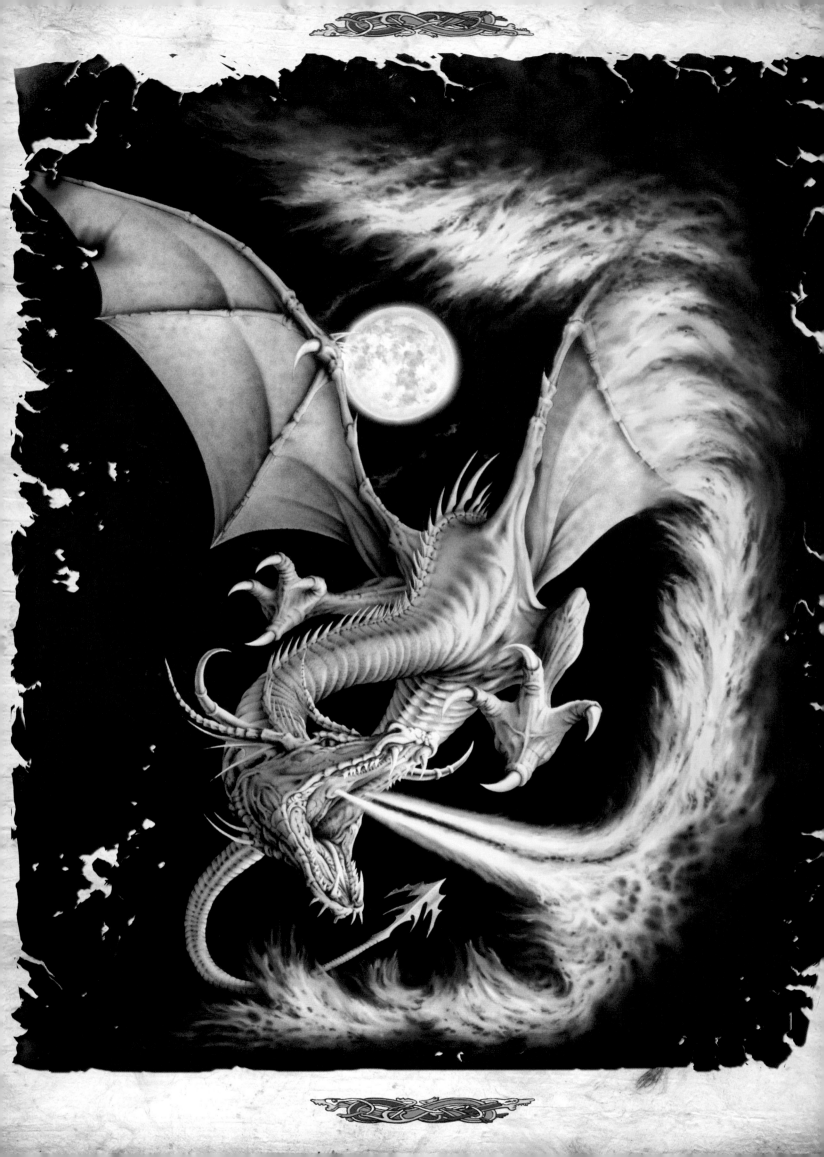

Outside, the dark clouds had dispersed and the landscape was bathed in late afternoon sunshine. There had been much loss of life in the final battle and it would be many years before the people of the Four Kingdoms overcame their grief but we had emerged victorious. I put my arms around Bandred's and Amaleh's shoulders and guided them gently to a balcony which overlooked the scene. Bandred turned towards me and, although I had looked into his eyes many times before, something had subtly changed. It was no more than a nuance but it had unmistakably marked the passage from boyhood into maturity.

As his gaze once again fell upon the tiny figures that dotted the hills around us and he surveyed his ravaged land I gave him the reassurance he seemed to need.

'Be strong for your people, Bandred – your time has come'.

Day Seventy-Six

This is to be my final entry in the journal and I am reminded that I was sitting at this very desk in my cliff top home many months ago when the King's letter arrived, bringing with it his desperate plea for help. Having fulfilled his request and survived the ensuing adventure, I find that I am much weakened by the experience but, curiously, I also feel more alive than I have for many a long year.

Amaleh has proved herself to be a bright and attentive student, her keenness to learn of the magic arts matched only by my desire to impart the knowledge I have gained over the centuries. When the time comes for me to join the elders of my kind on the other side I know that I shall leave behind a truly worthy successor, and that the new King will have the unfailing devotion of a loyal servant for the duration of his reign.

Glossary

Beast of Gremarnaca — Two-headed dragon from the upper reaches of the Gordacas Canyon.

Dragon of Kargan — Large dragon which resides in the Lost Valley of Skernia.

Dragon of the North — Most feared dragon in the Four Kingdoms, residing in the high peaks of the Fincormach Mountains.

Dragonets — Tiny but extremely aggressive miniature dragons, noted for their tendency to swarm.

Gorlenah — Dragon which took up residence at Sankara Castle after driving out its inhabitants and was later exorcised by Septimus

Great Beast of Gratnor — Large dragon, now completely blind, which resides in the Caves of Vor.

The Dark Dragon of Demonica — The very essence of evil, in spirit form.

Amaleh — A sixteen-year-old female stowaway whose past is a mystery.

Bandred di Sandorius — Son of Malacan, and heir to the throne.

Bensandas — Lord of the Caverns of Vor.

Captain Archemon — Spy recruited by Ganzicus to report on the mission's progress.

Captain Kronson — One of the most experienced warriors under Septimus's command and the only one capable of controlling Gorlenah in flight

Ferdinand — Warrior who was lost to the Dragon of the North.

Ganzicus — Wizard, and erstwhile servant of the King, now shamed and living in exile.

Malacan di Sandorius — Sovereign Ruler of the Four Kingdoms.

Septimus Agorius — Supreme Wizard to the King's Court, keeper of the journal, and close personal friend of the Sovereign.

Varien Marner — A farmer from the Third Kingdom.

Amandan Forest — Extensive wooded area in the lower part of the Western Kingdom.

Archipelago of Denisarnda — Complex group of islands in the South West area of the Pharamond sea.

Arken Island — Small rocky outcrop to which Ganzicus was exiled, situated in the Pharamond Sea.

Arrean Mountains — A range of snow-capped peaks which begins at the head of the Gordacas Canyon and occupies the Northernmost section of the Western Kingdom.

Avarigan Plain — Vast sun-baked plateau at the foot of the Vorgamon Mountains.

Brooke's Bay — The point where the mission made landfall in the Southern Kingdom.

Castle Ursicus — Fortress sited on the coast of the Southern Kingdom.

Caverns of Vor — Labyrinthine cave system which passes under the inhospitable landscape known as the Terra Balena.

Fincormach Mountains — Situated in the most inaccessible tip of the Northern Kingdom, this range is the highest in the land.

Ghazeen Valley — An outstandingly beautiful part of the Eastern Kingdom, later defiled by Ganzicus's evil influence.

Gorensen Crag — A spectacular granite fissure situated high in the Fincormach Mountains, thought to be the site of the Dragon of the North's lair.

Isles of Waltan — Situated in the centre of the Pharamond Sea, this small cluster of barren rocks provided temporary shelter for Septimus's ship in the early stages of the voyage.

Jorgas Mountains — A relatively low range situated to the North East of Villiandra.

Kror Passage — Tunnel which bypasses the more precipitous sections of the Vorgamon Mountains.

Lost Valley of Skernia — Dramatic canyon which lies in the shadow of the Vorgamon Mountains in the Eastern Kingdom.

Pharamond Sea — Expansive stretch of water dividing the Eastern and Western Kingdoms.

Sankara Castle — Impressive fortress ringed by lakes and located in the Eastern Kingdom.

Sea of Aleph — Body of water which borders the Western coast of the Western Kingdom and runs into the Archipelago of Denisarnda in the South.

Terra Balena — Impassable landscape in the Eastern Kingdom, notable for its exotically shaped rock formations.

Tremana — Gateway port to the Western Kingdom.

Veliden Pass — Path which leads out of the Ghazeen Valley towards Sankara.

Villiandra — Capital of the Four Kingdoms, and home to the King.

Vorcan Portal — Entrance to the Caves of Vor.

Ballister — Very powerful deck-mounted weapon which can be used to propel a variety of missiles.

Henscher Ring — An elaborate and highly charged engraving on the floor of a special chamber at Sankara.

Madagan Crossbow — Large, wagon-mounted weapon capable of firing a lance.

Sankara Amulet — Turquoise stone suspended within concentric gold rings, justly famed for its mystical powers.

The Book of Serafan — Ancient tome containing complex and powerful magic which is understood by only the most senior practitioners.

The Hejira — The vessel in which Septimus Agorius travelled.

The Verana — Ship that was lost to the great whirlpool in the Pharamond Sea.